# COLORING BOOK FOR ADULTS

# 100 UNIQUE AMAZING PATTERNS

THIS BOOK BELONGS TO

_____

_____

©2019 Mandala Artfulness. All rights reserved
Contact: ma@blondea.com

# COLORING TIPS

We have printed the art in single-sided pages. Each image is placed on its own black-backed page to reduce the bleed-through to the next image.

If you are using markers, it strongly recommended sliding a piece of cardstock or thick paper behind the page you are working on to make sure the ink doesn't stain the next page.

Now Relax and enjoy the "ME" Time

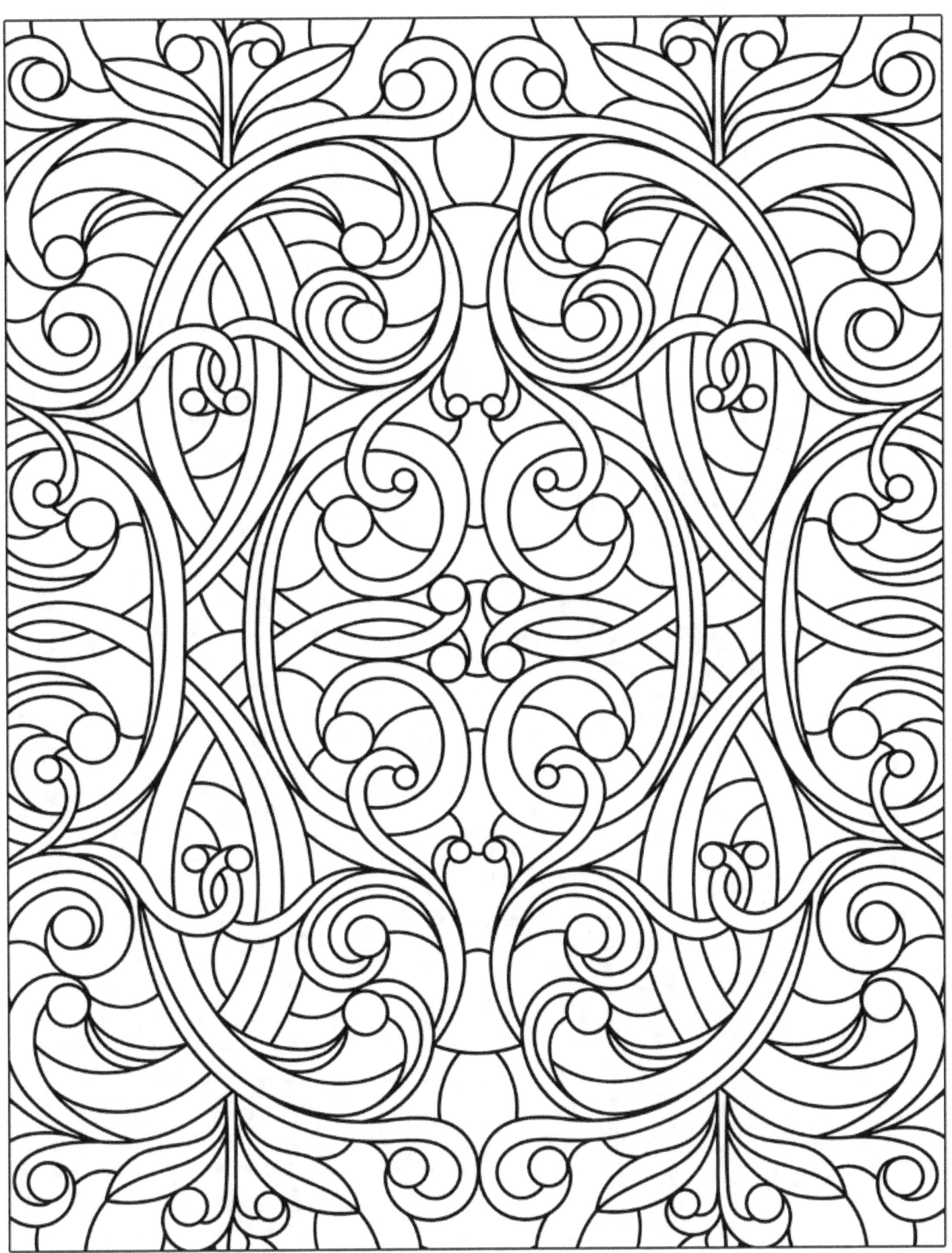

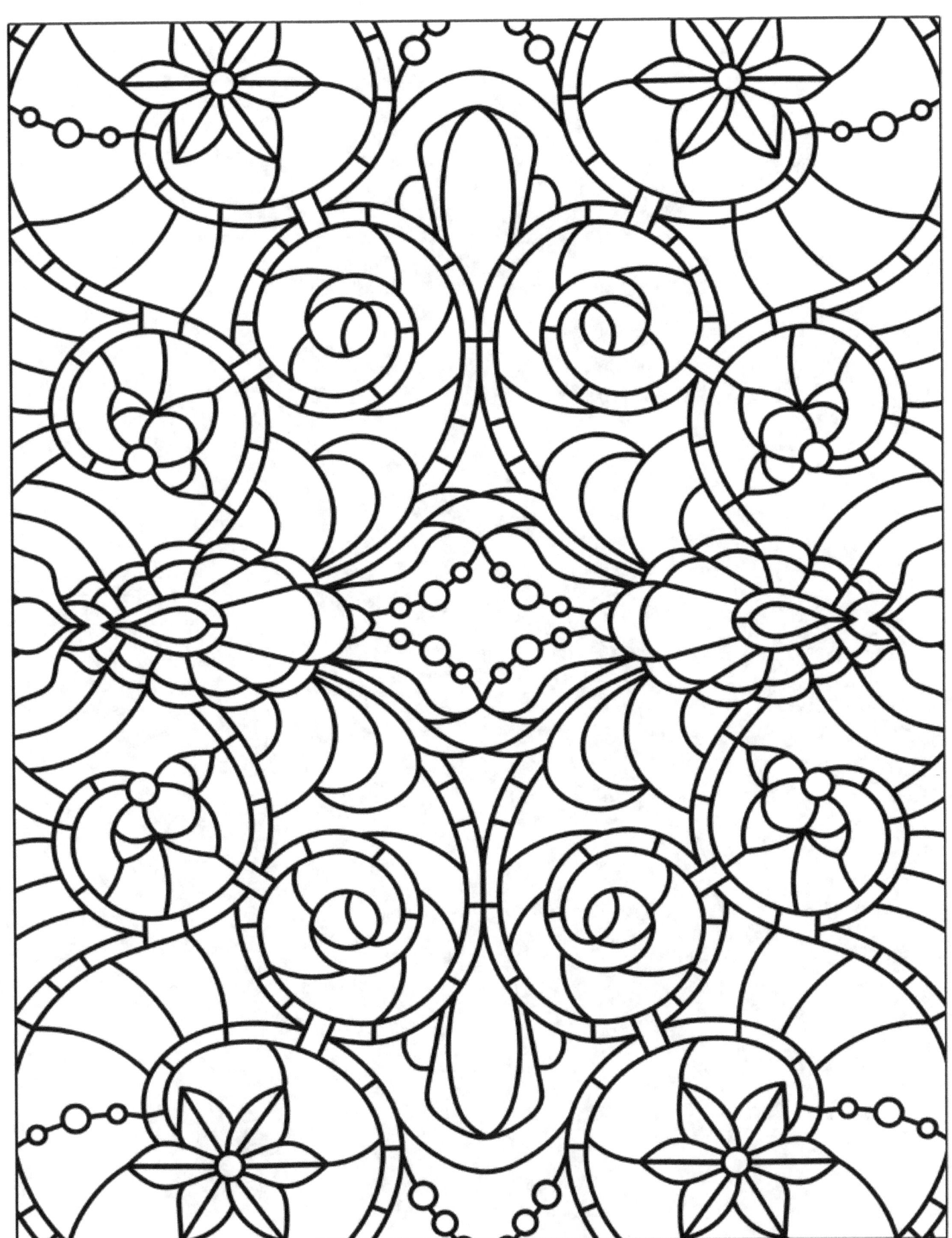

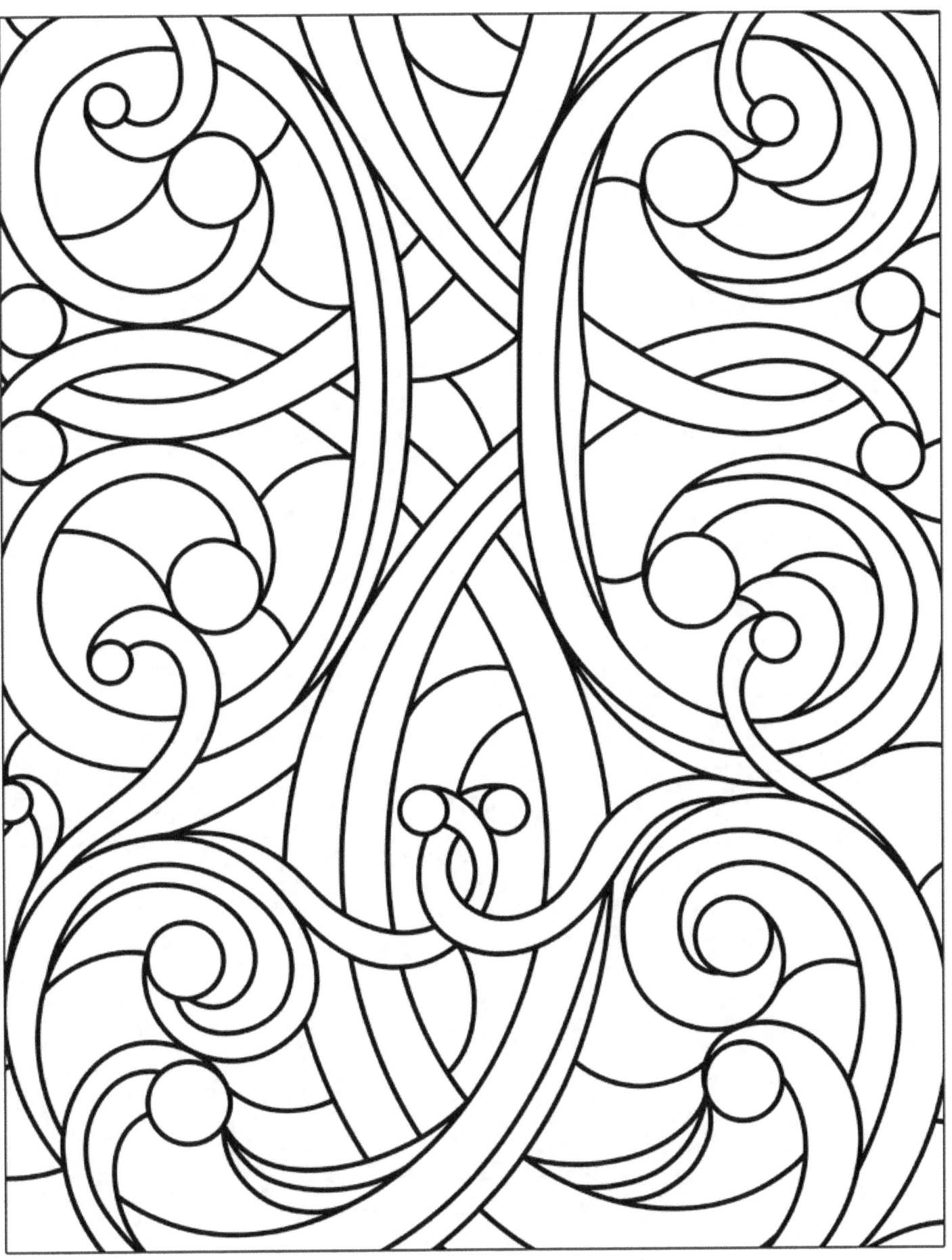

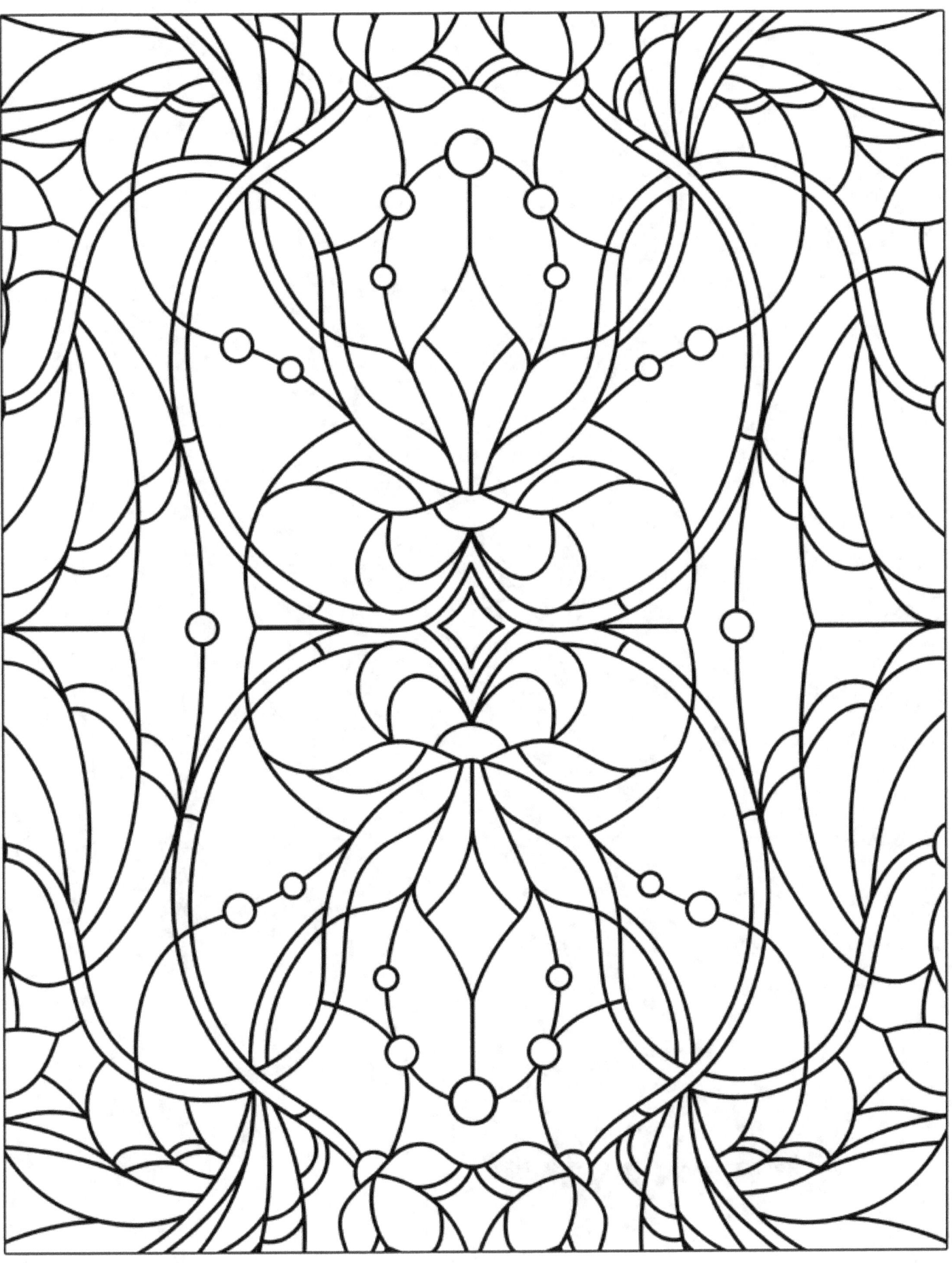

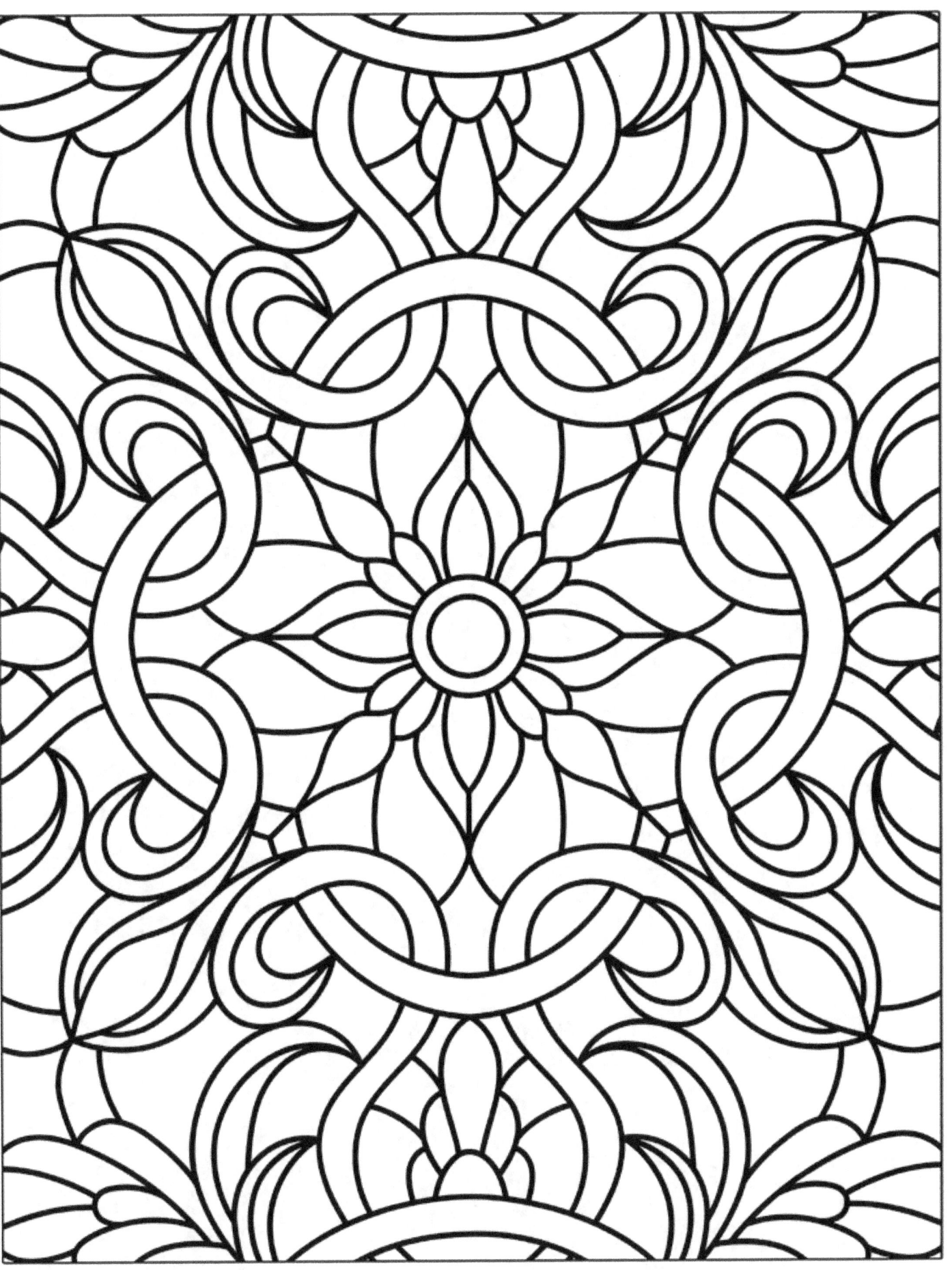

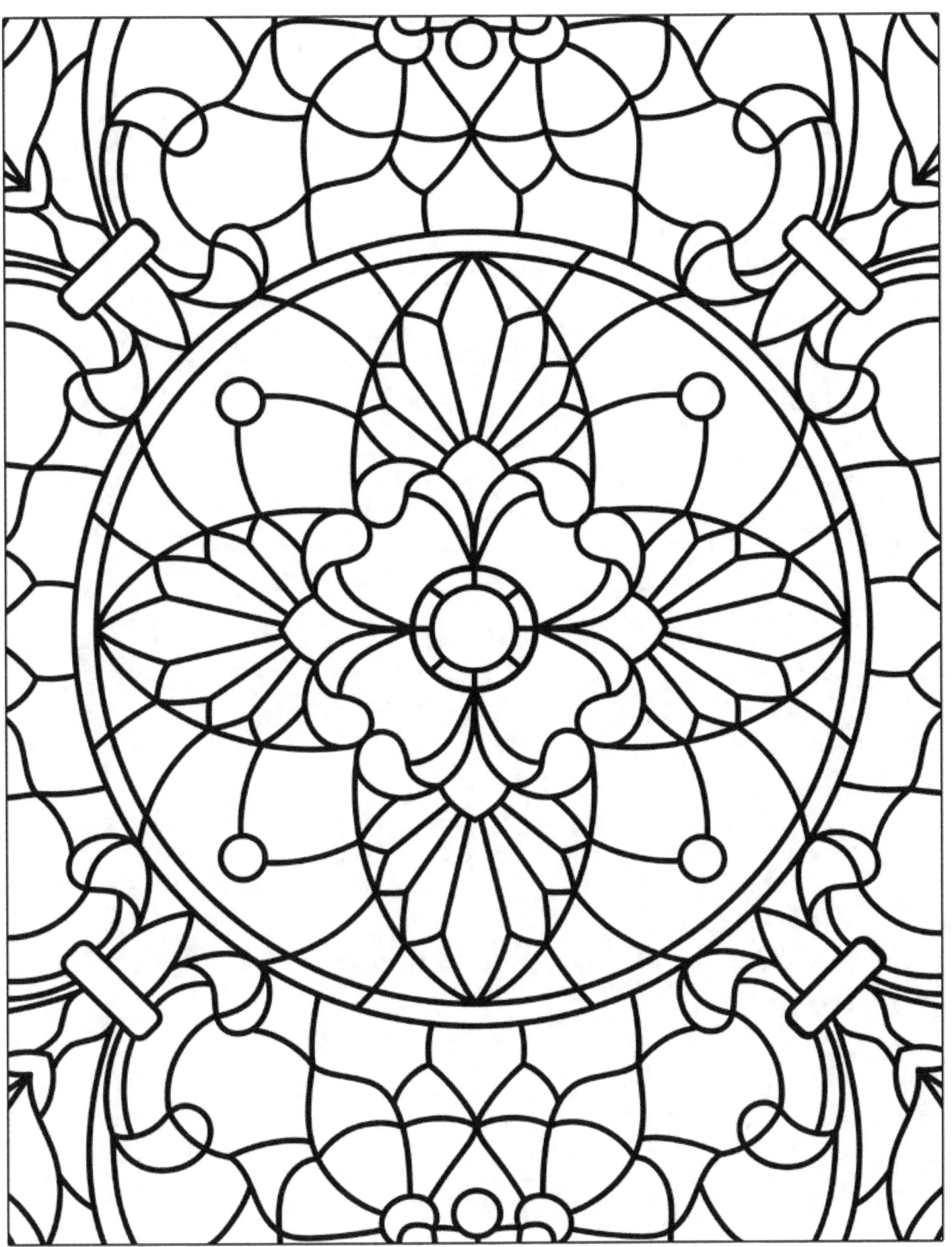

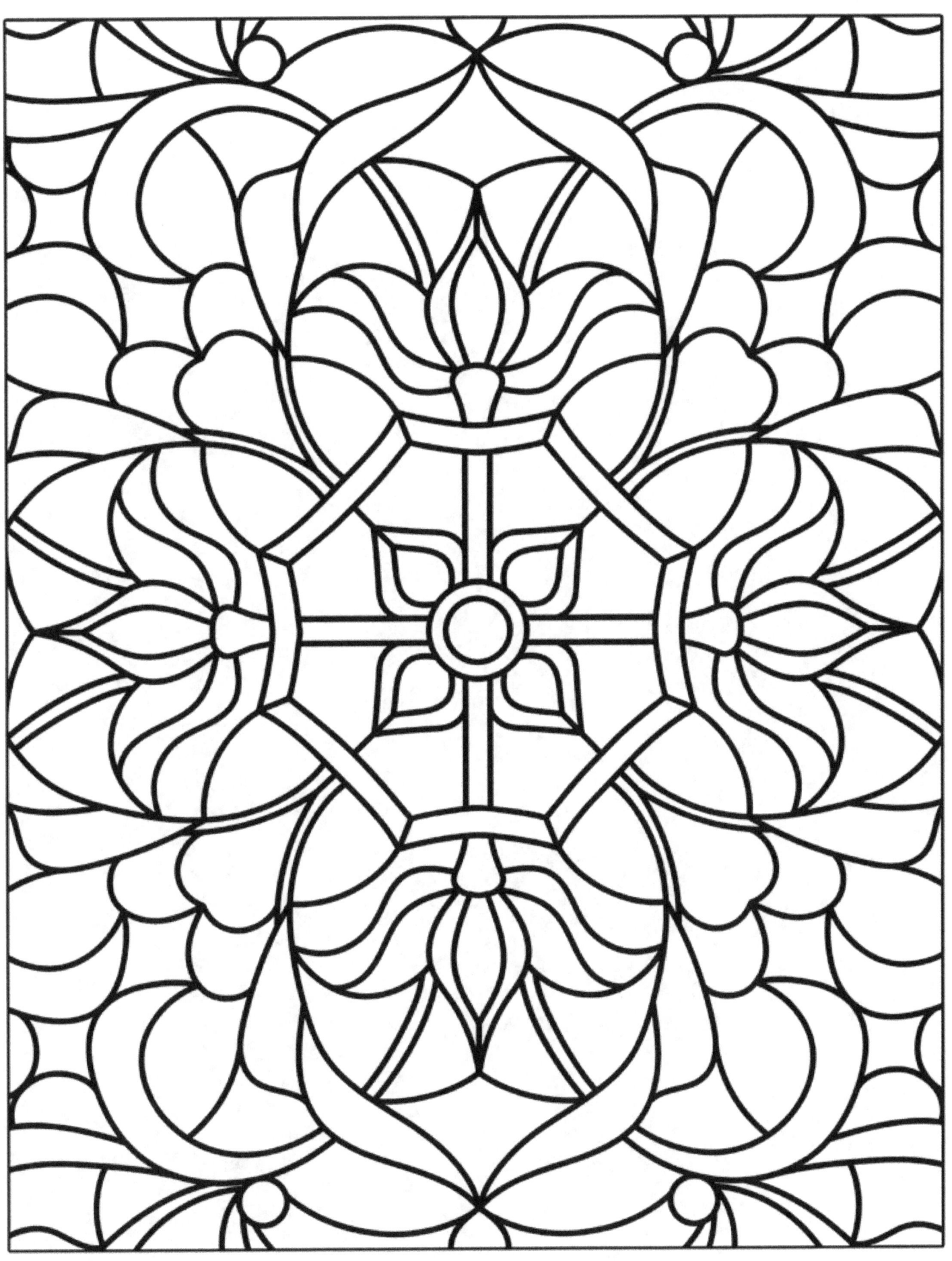

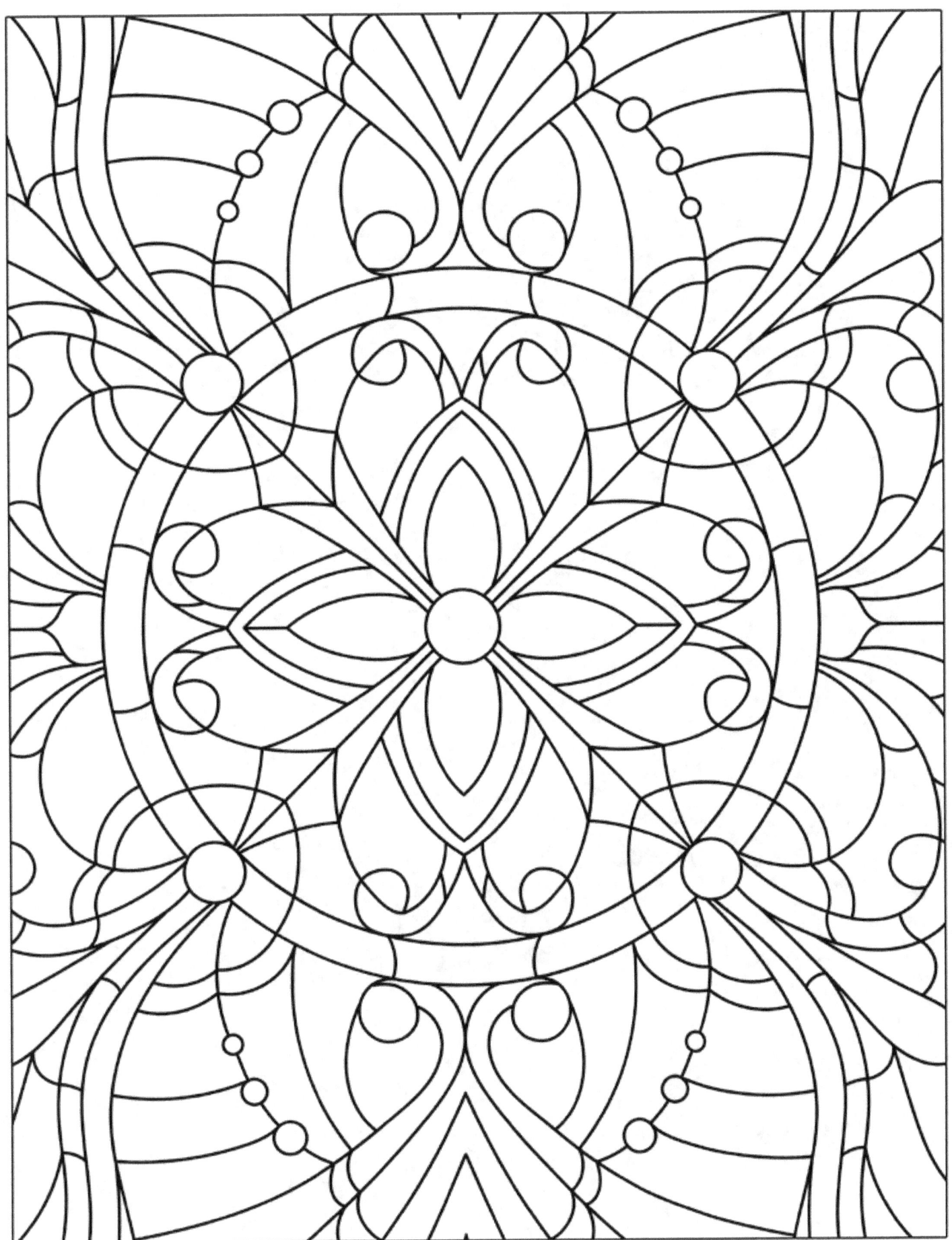

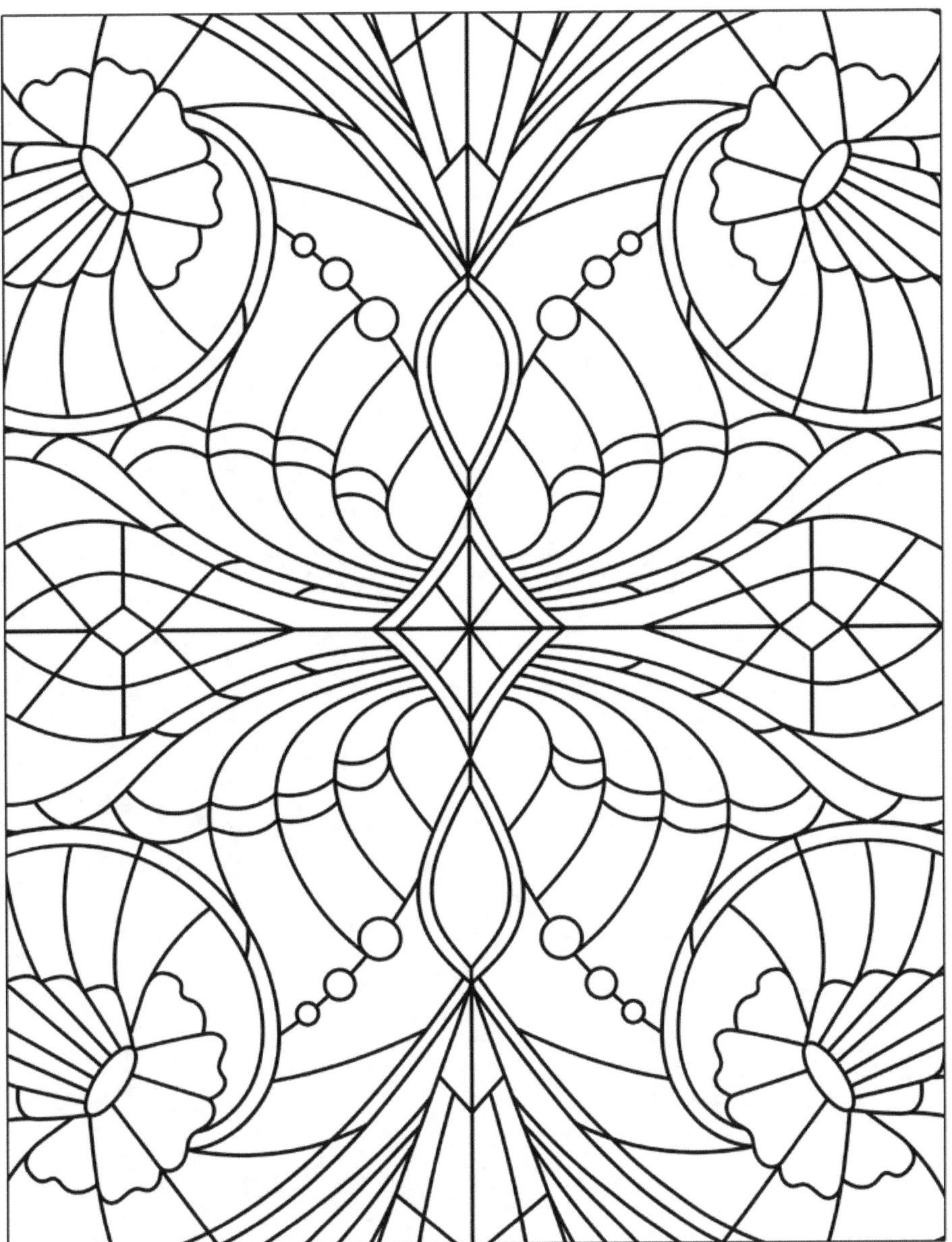

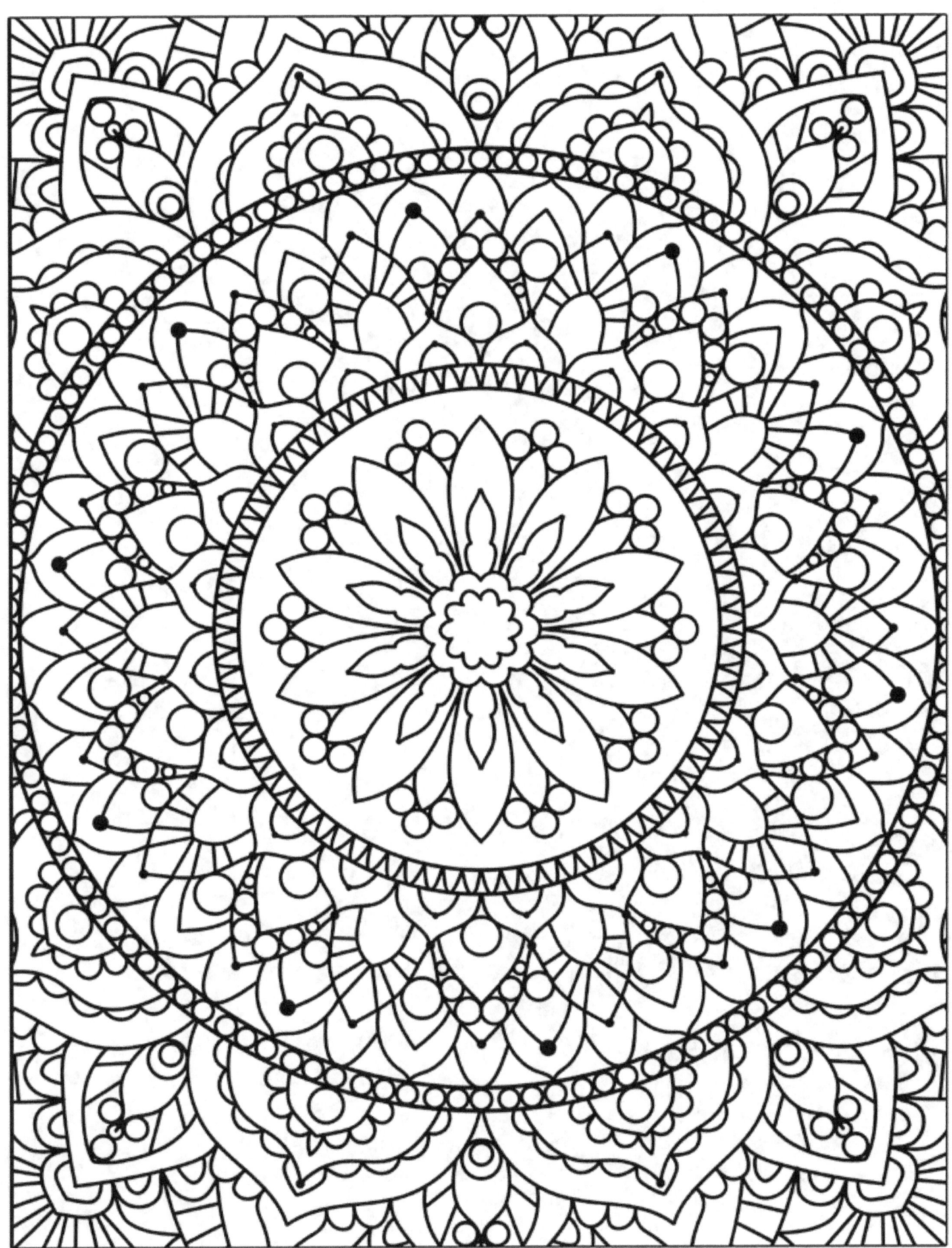

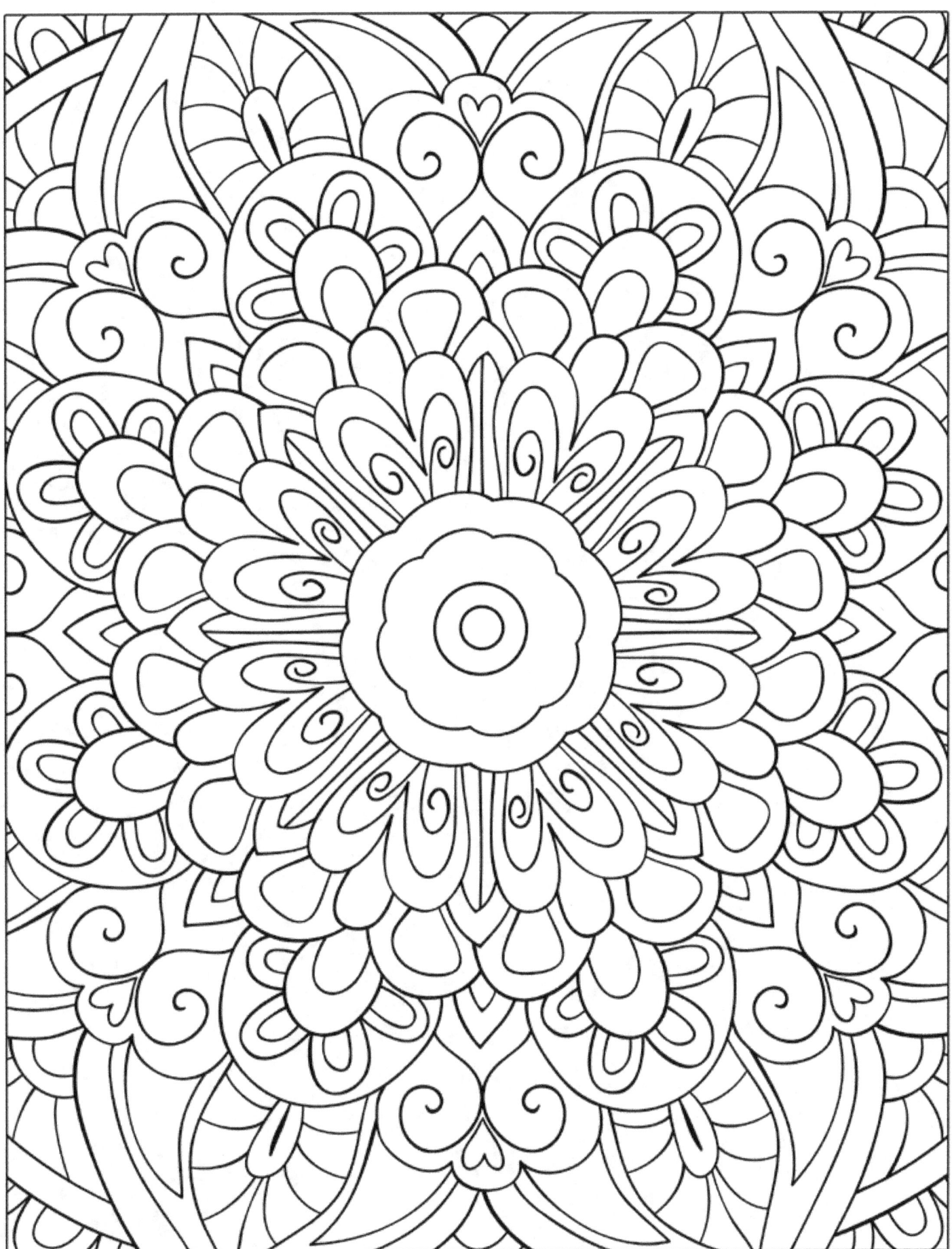

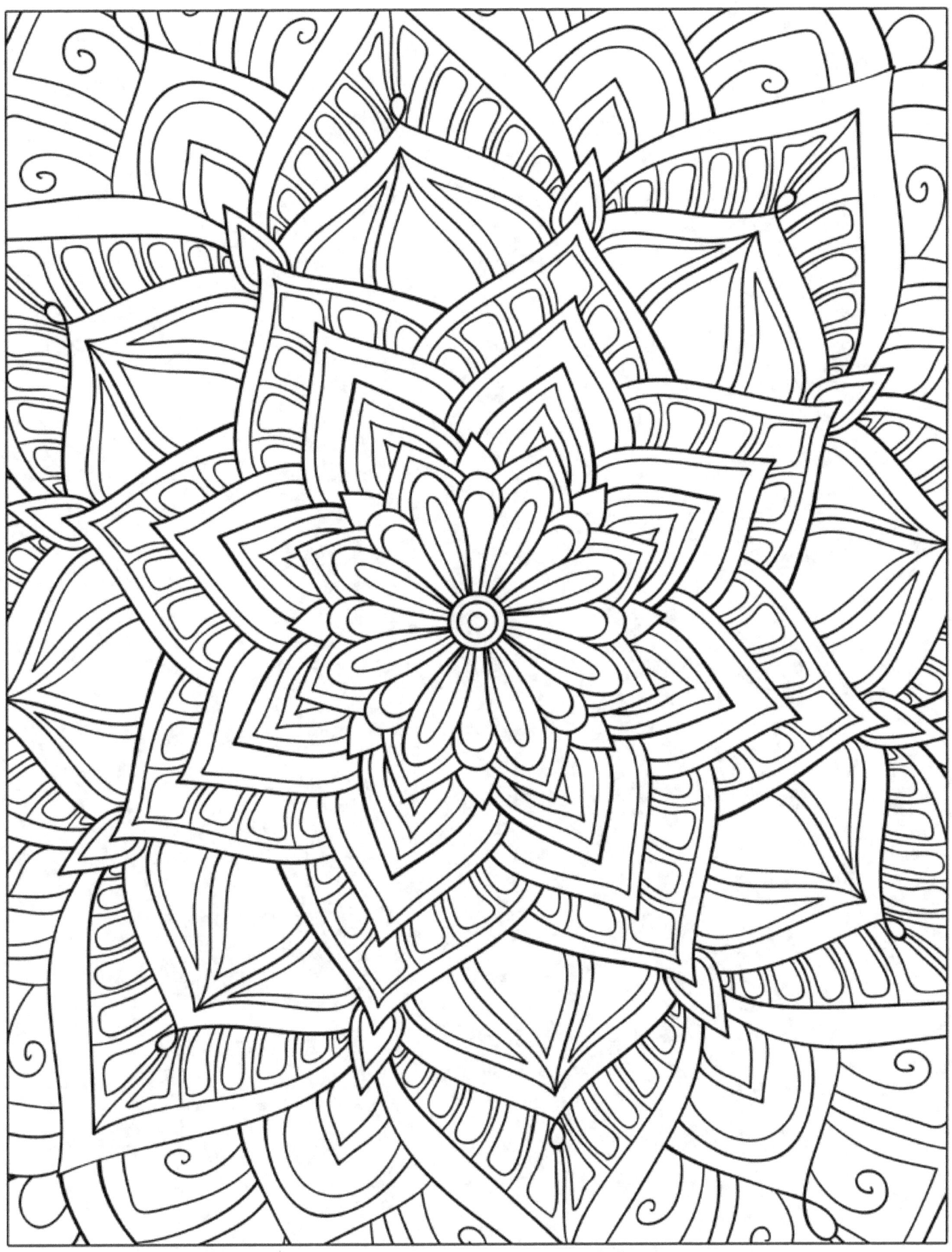

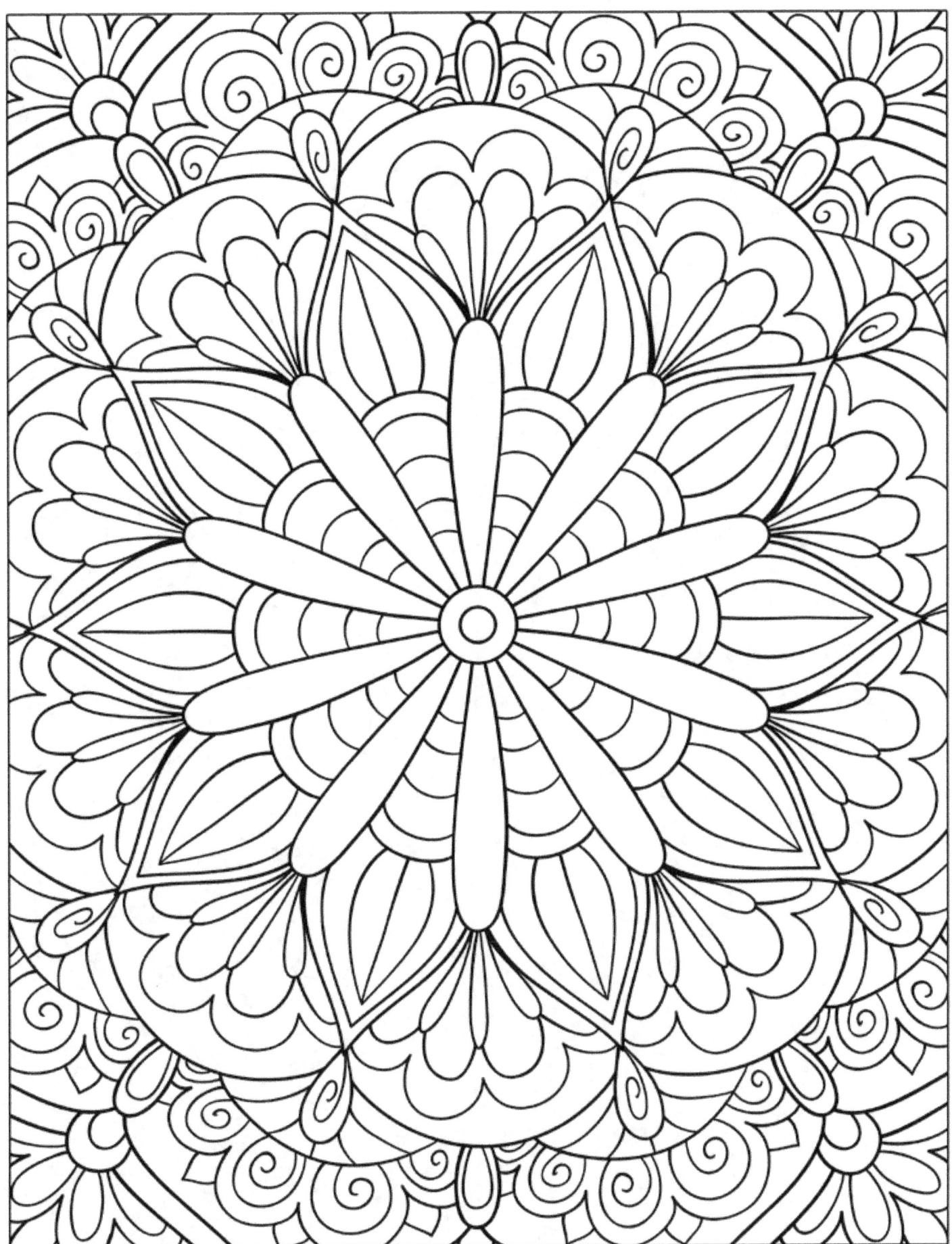

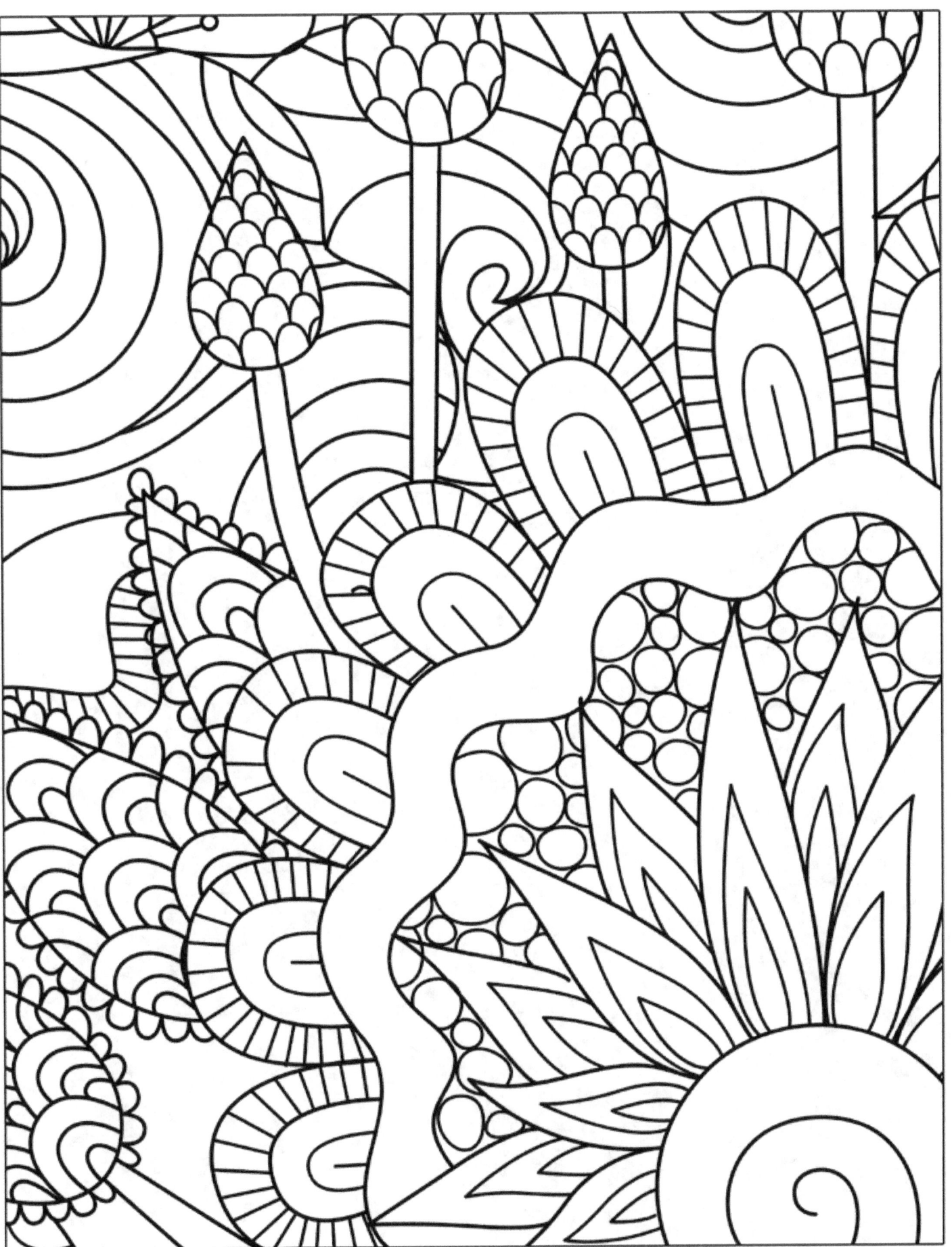

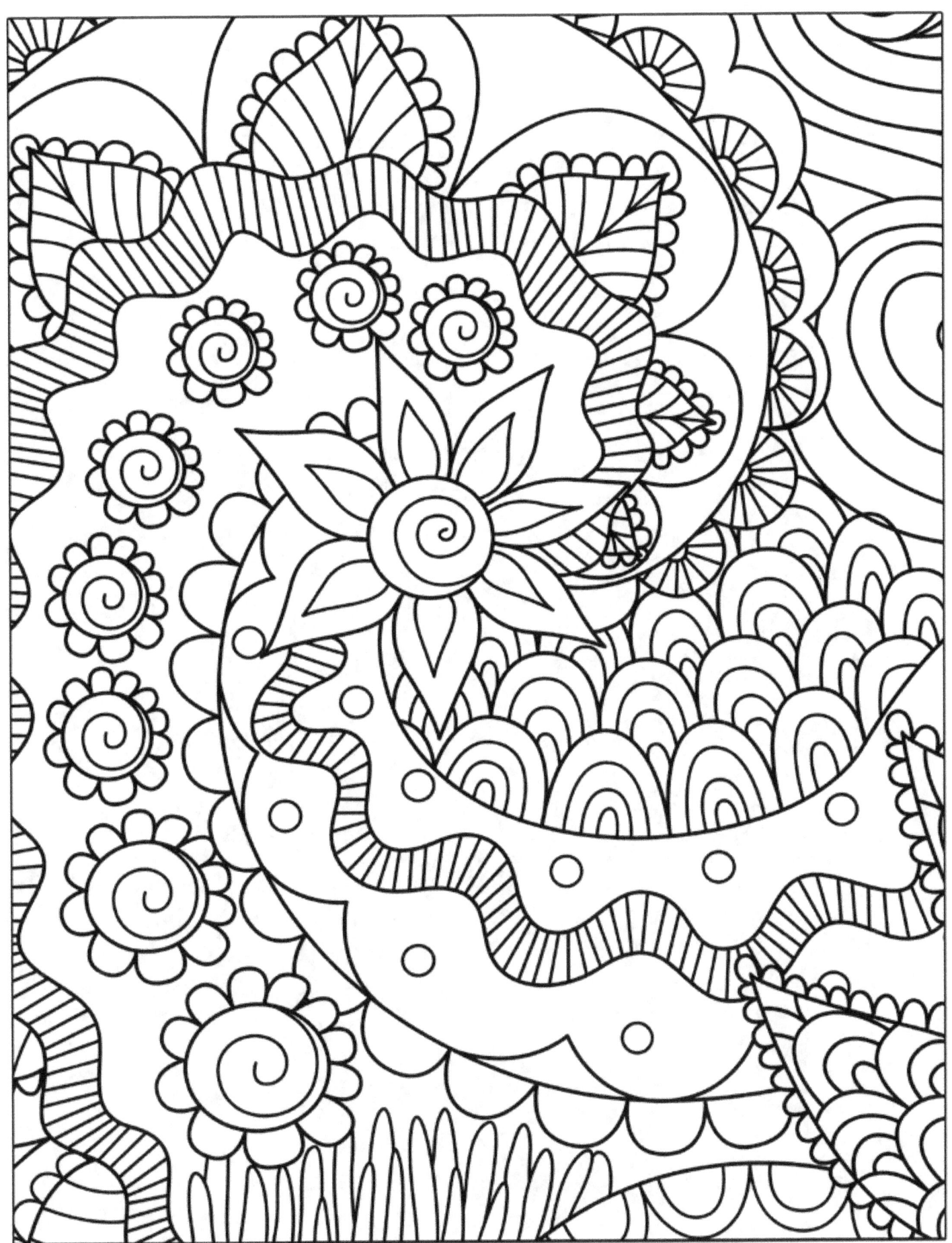

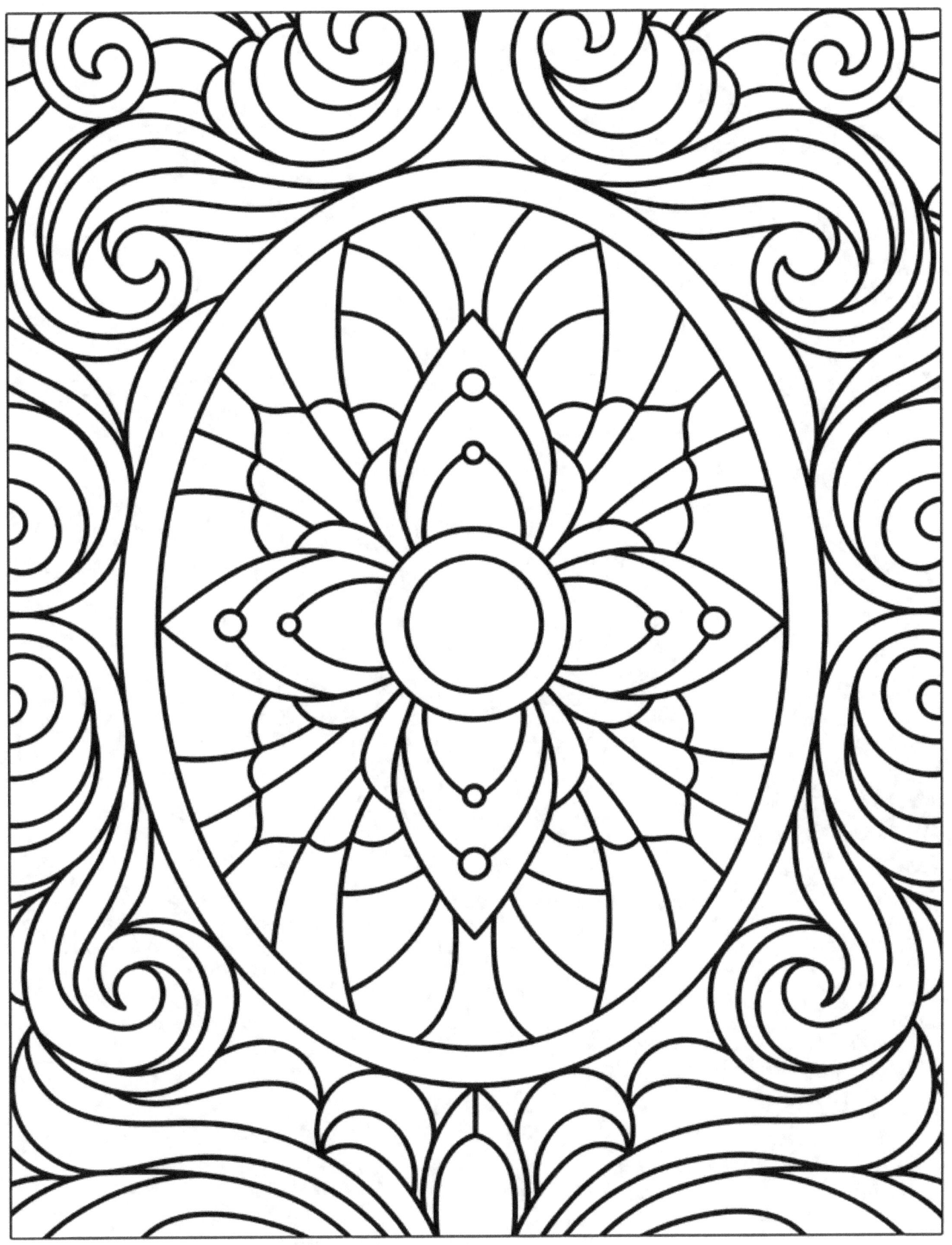

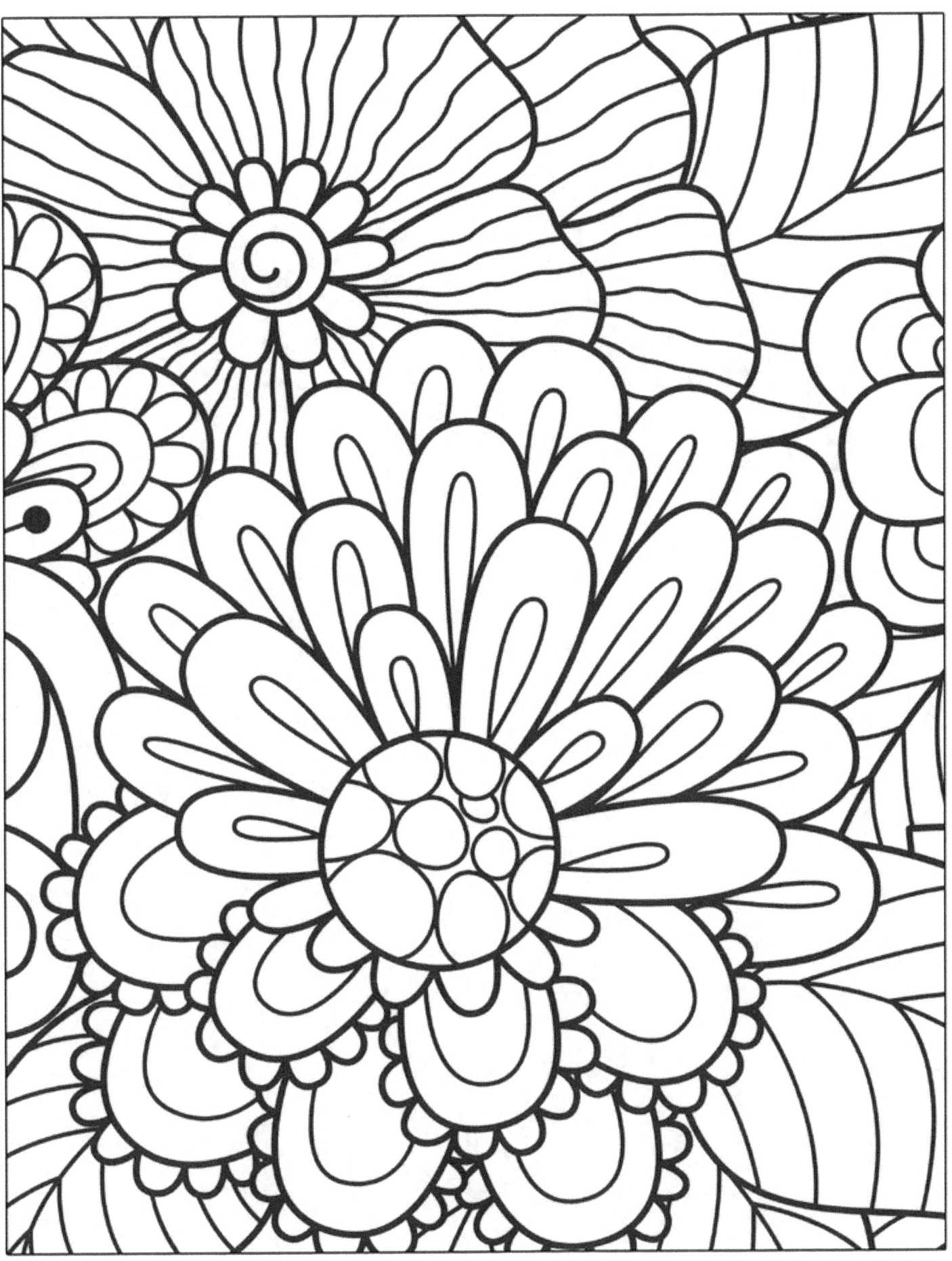

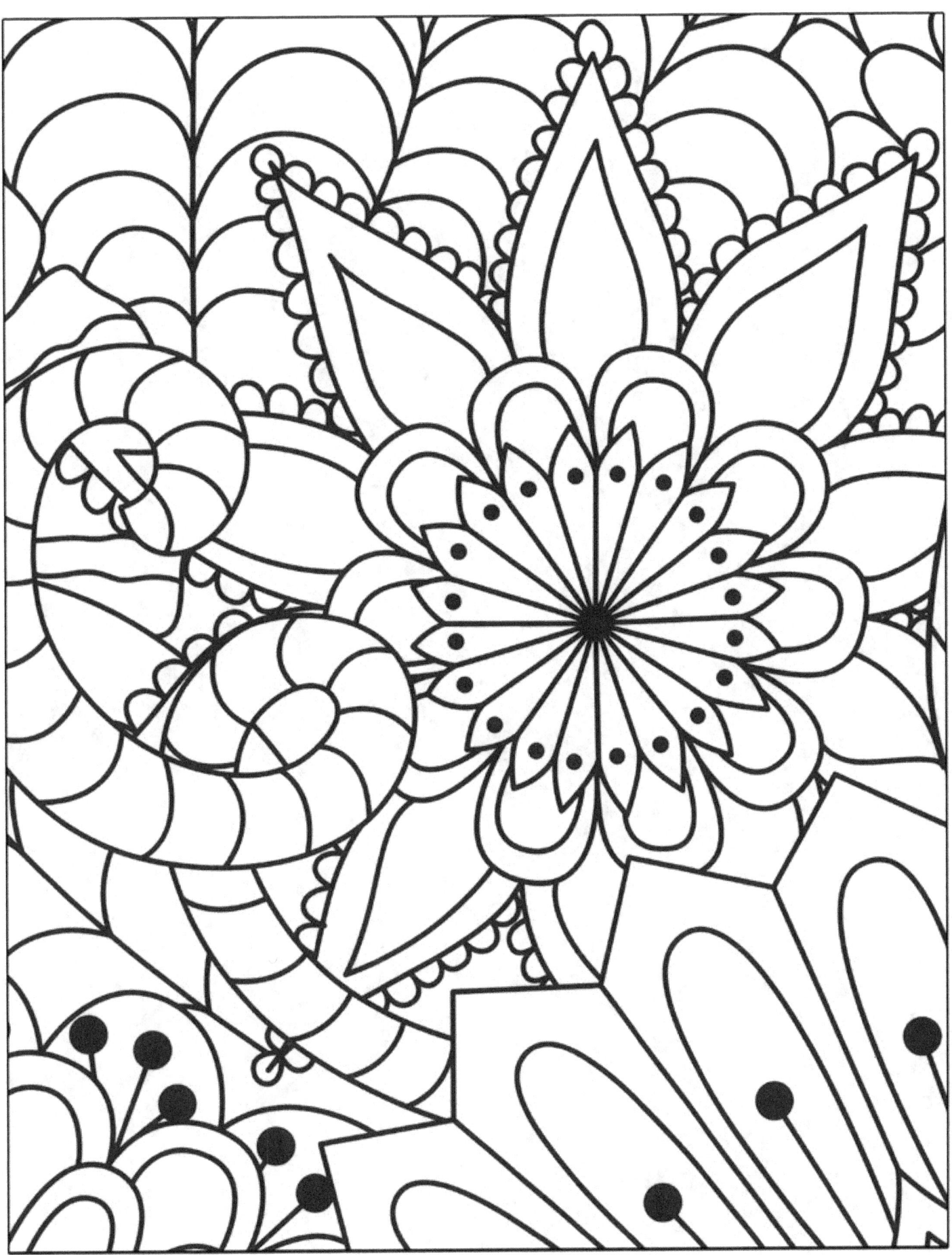

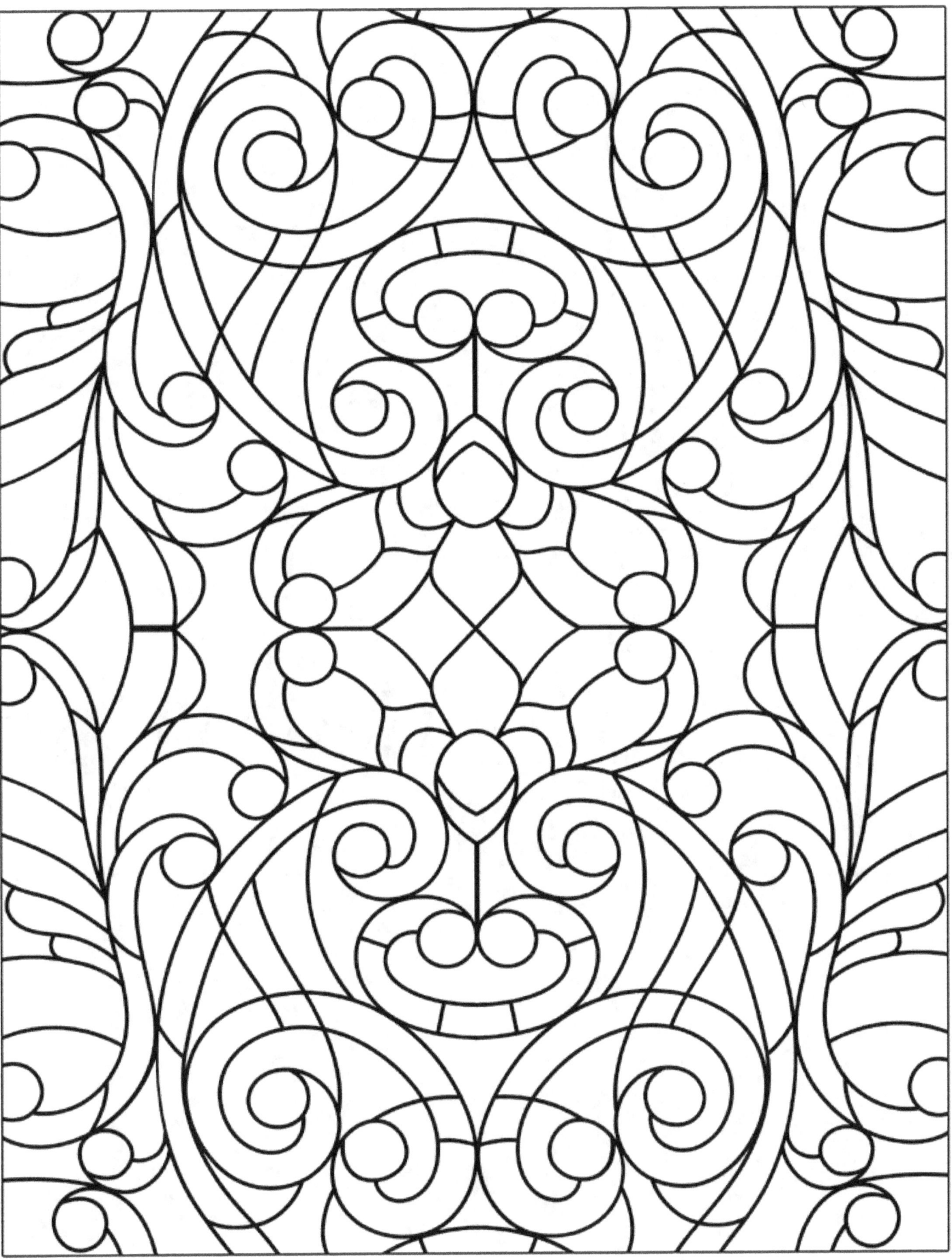

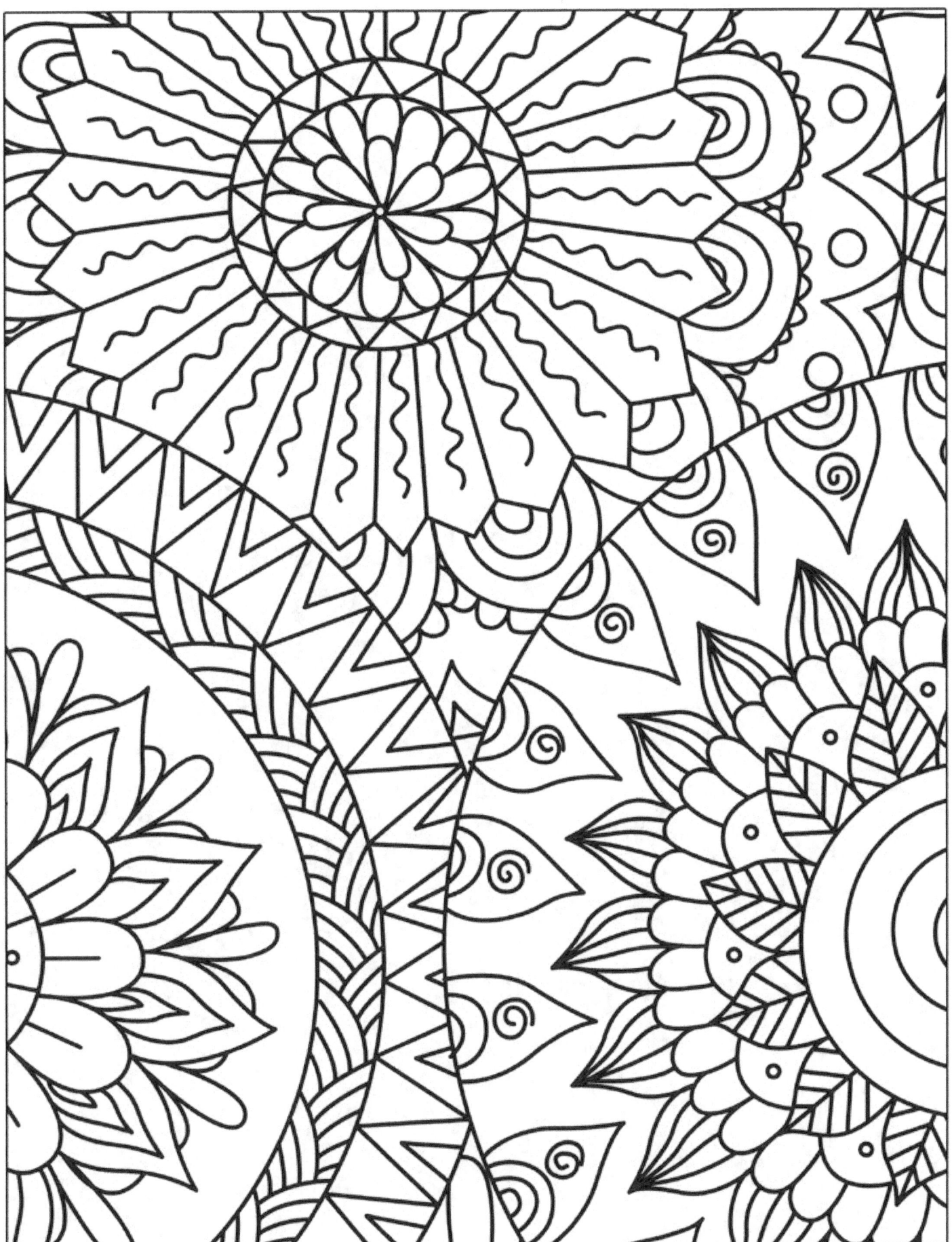

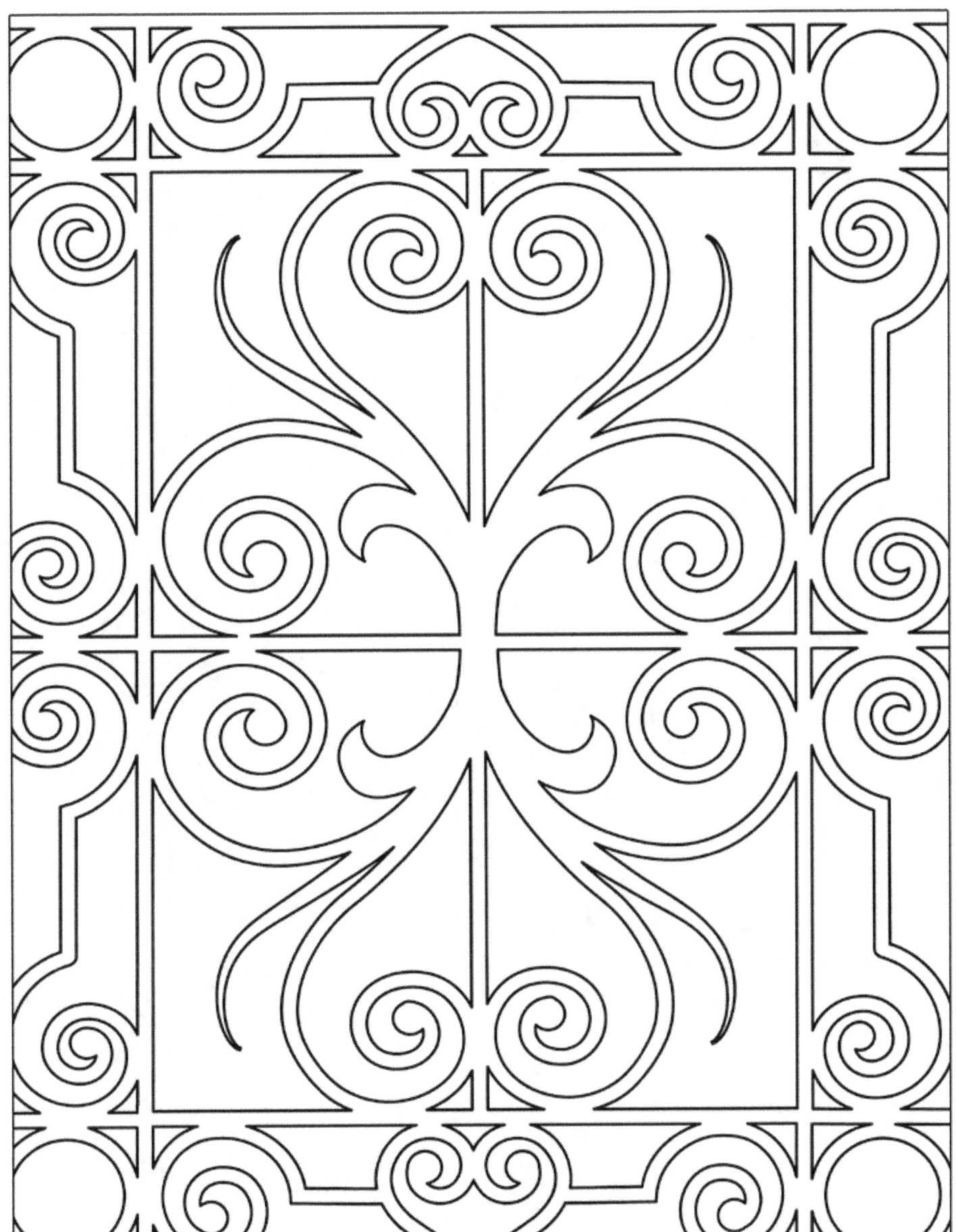

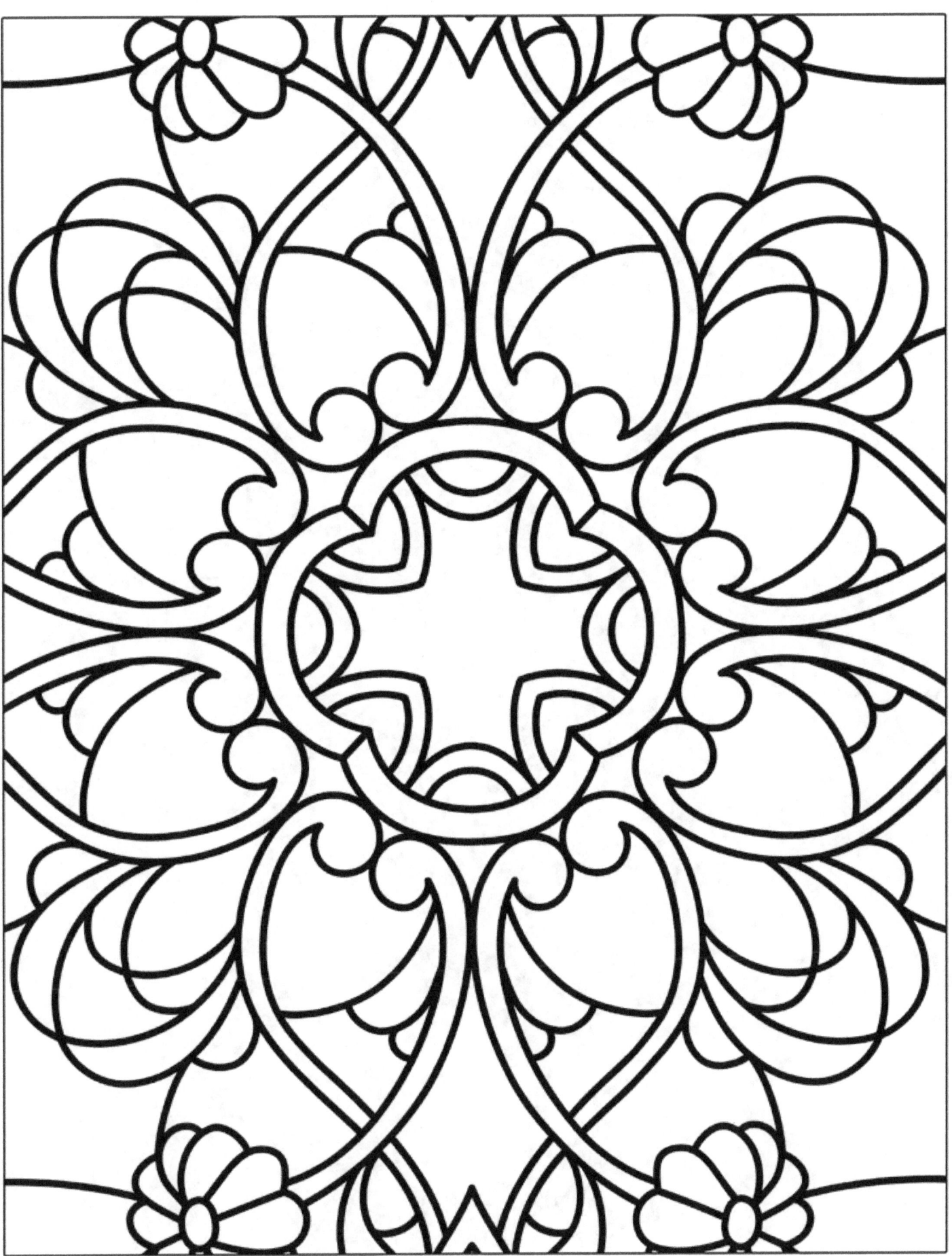

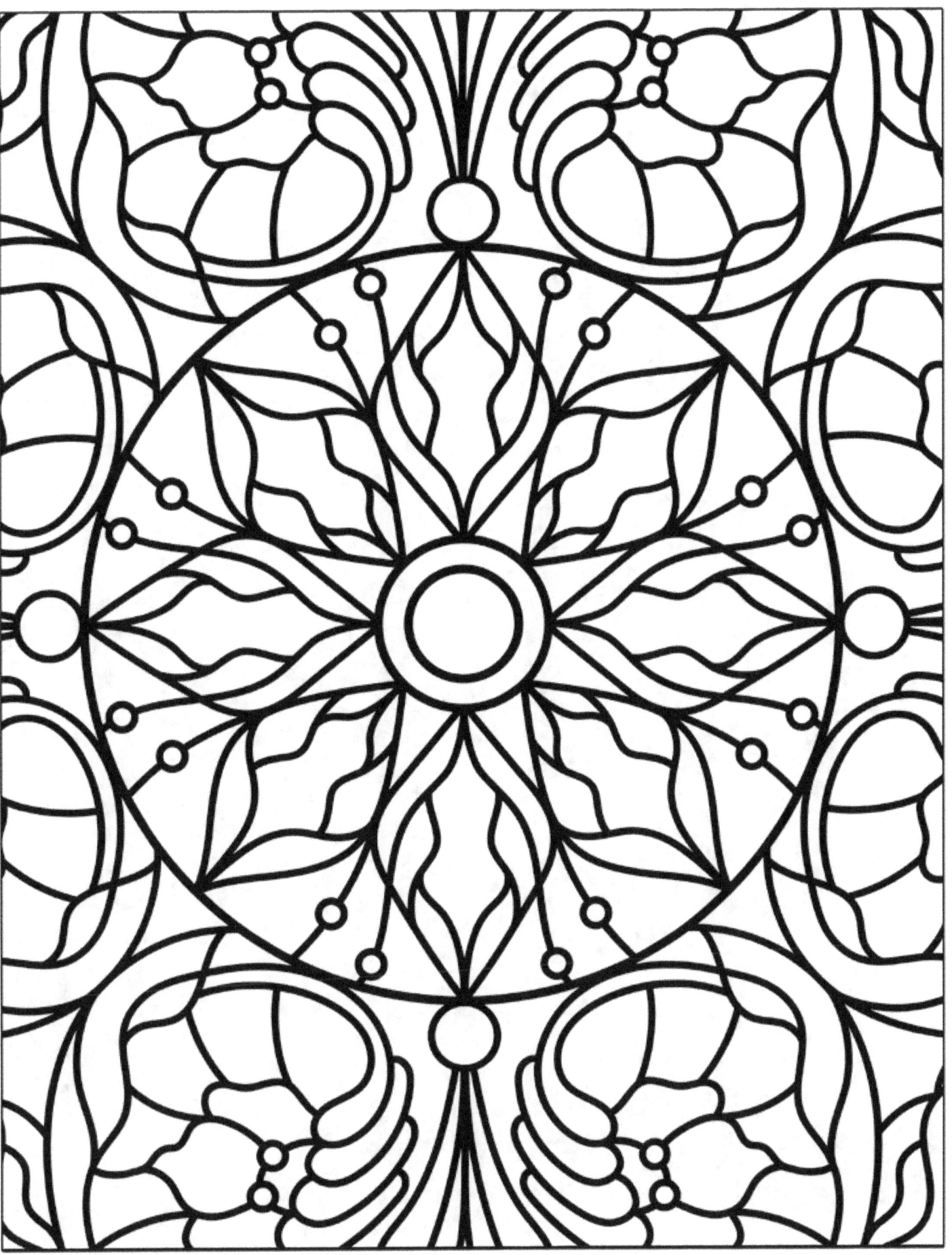

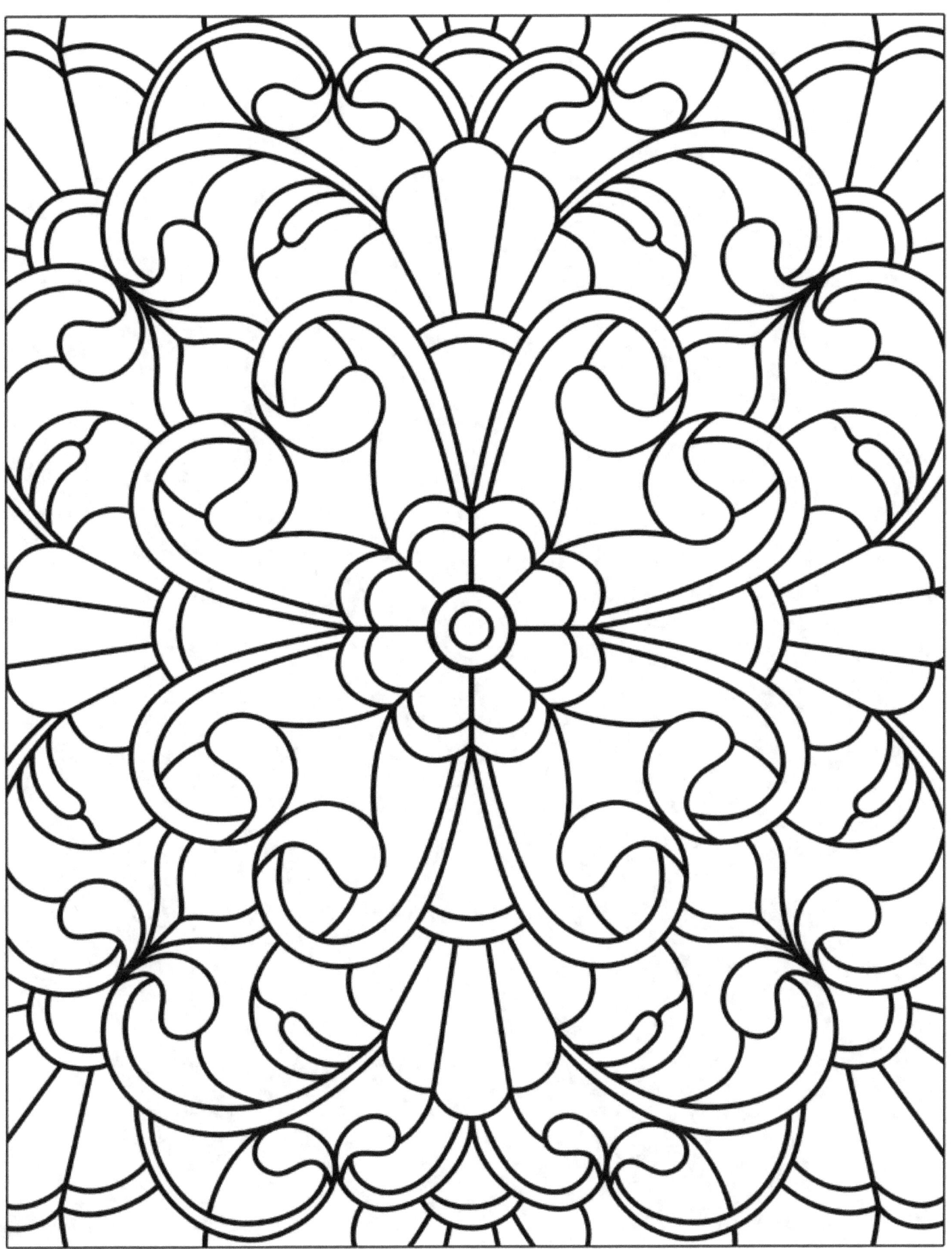

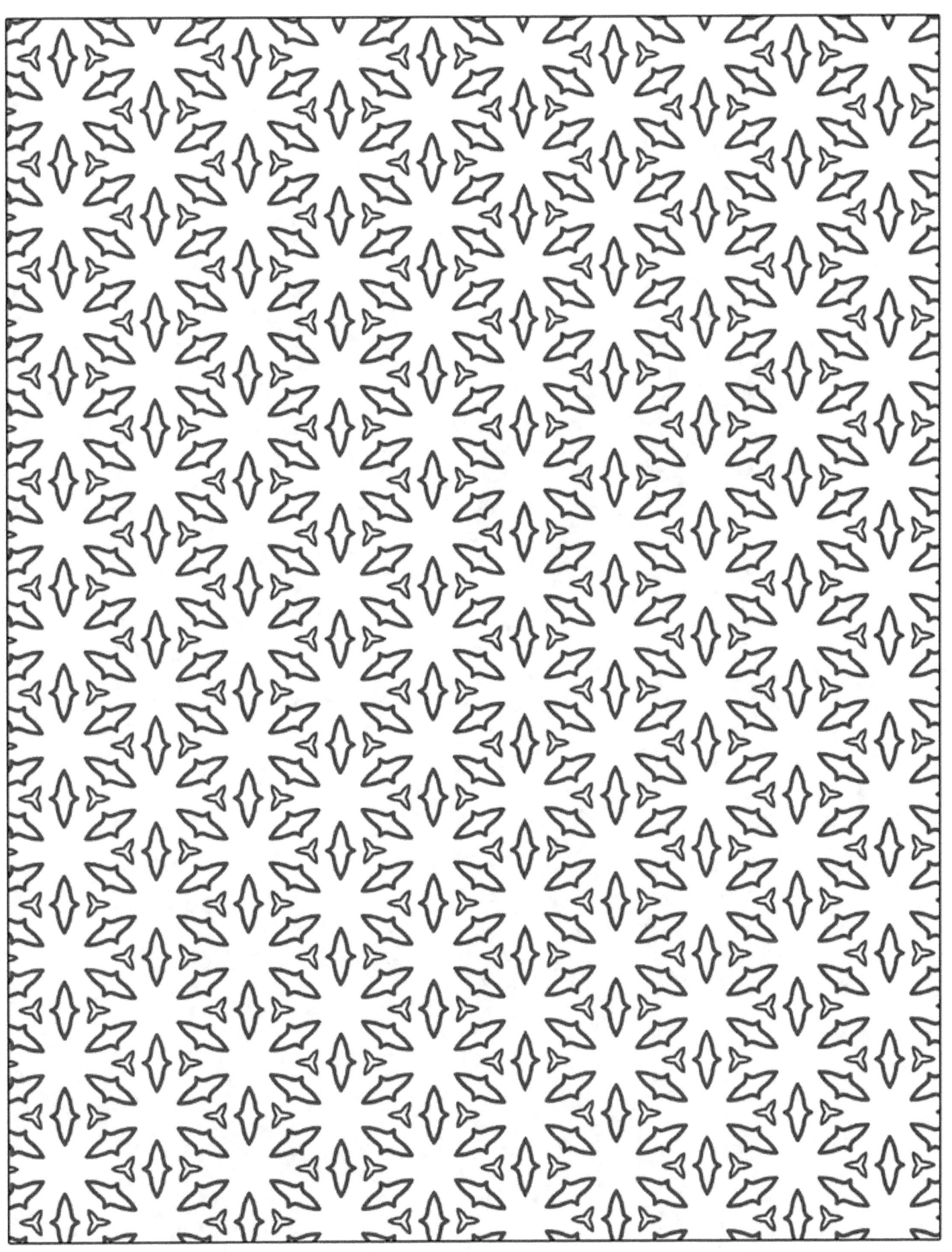

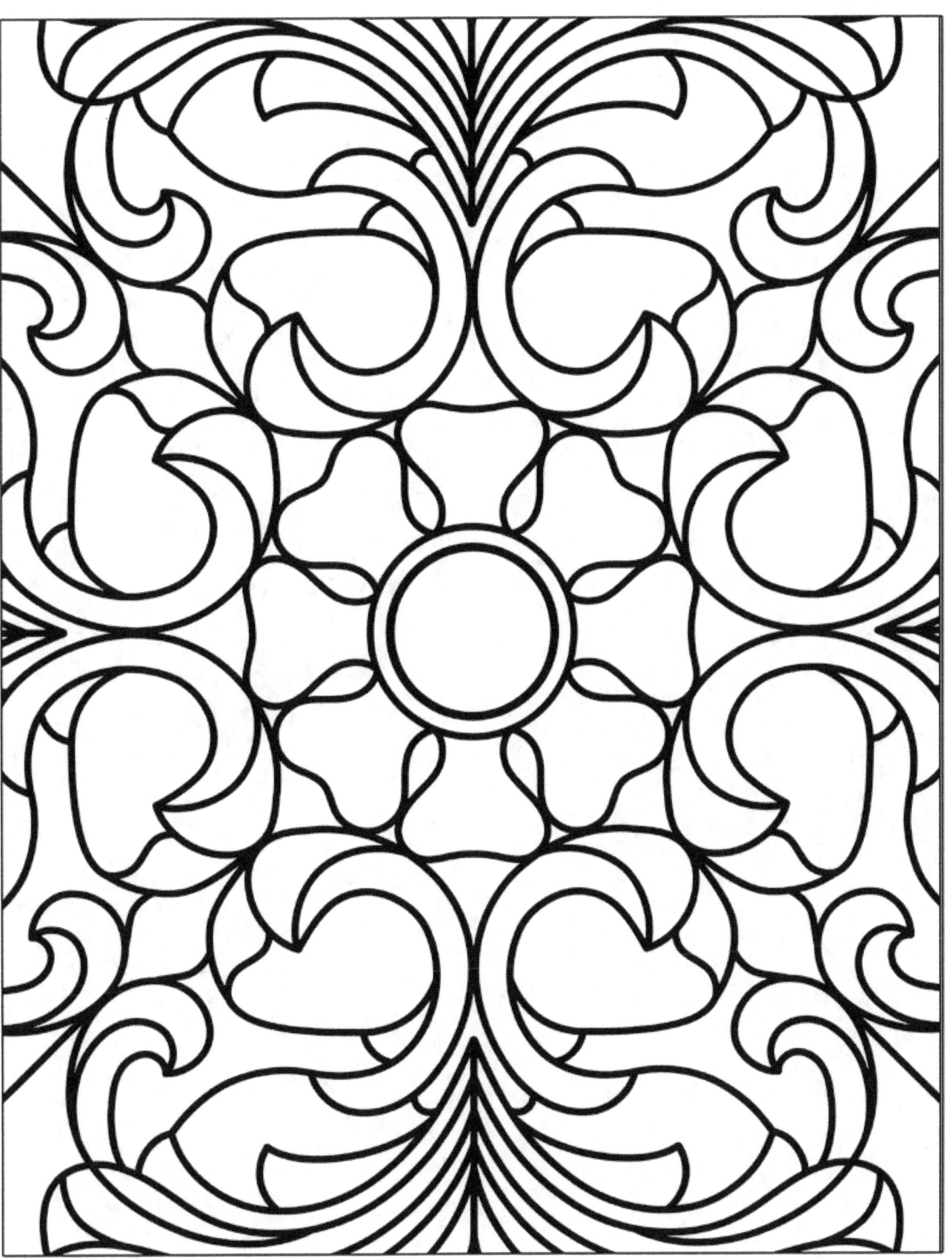

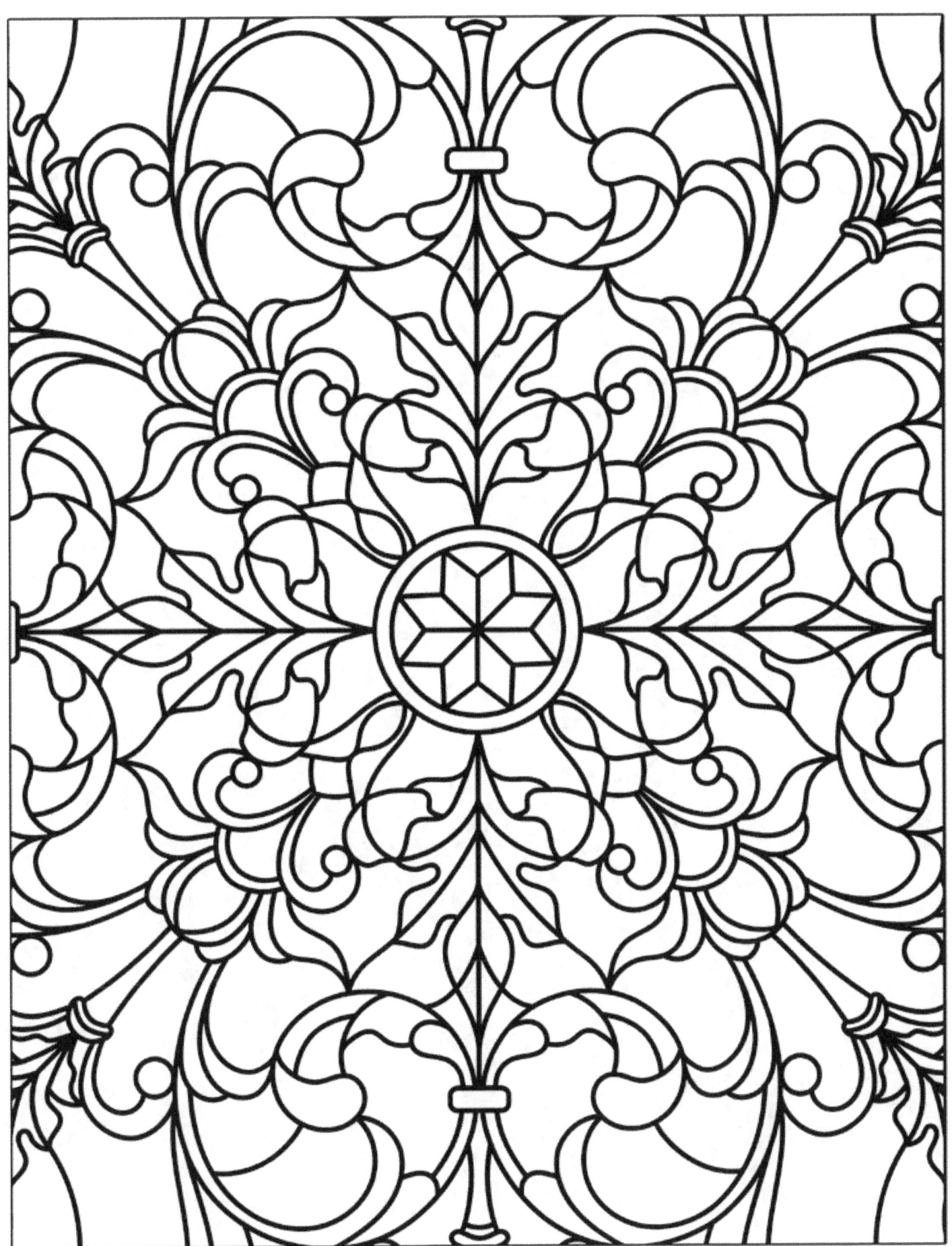

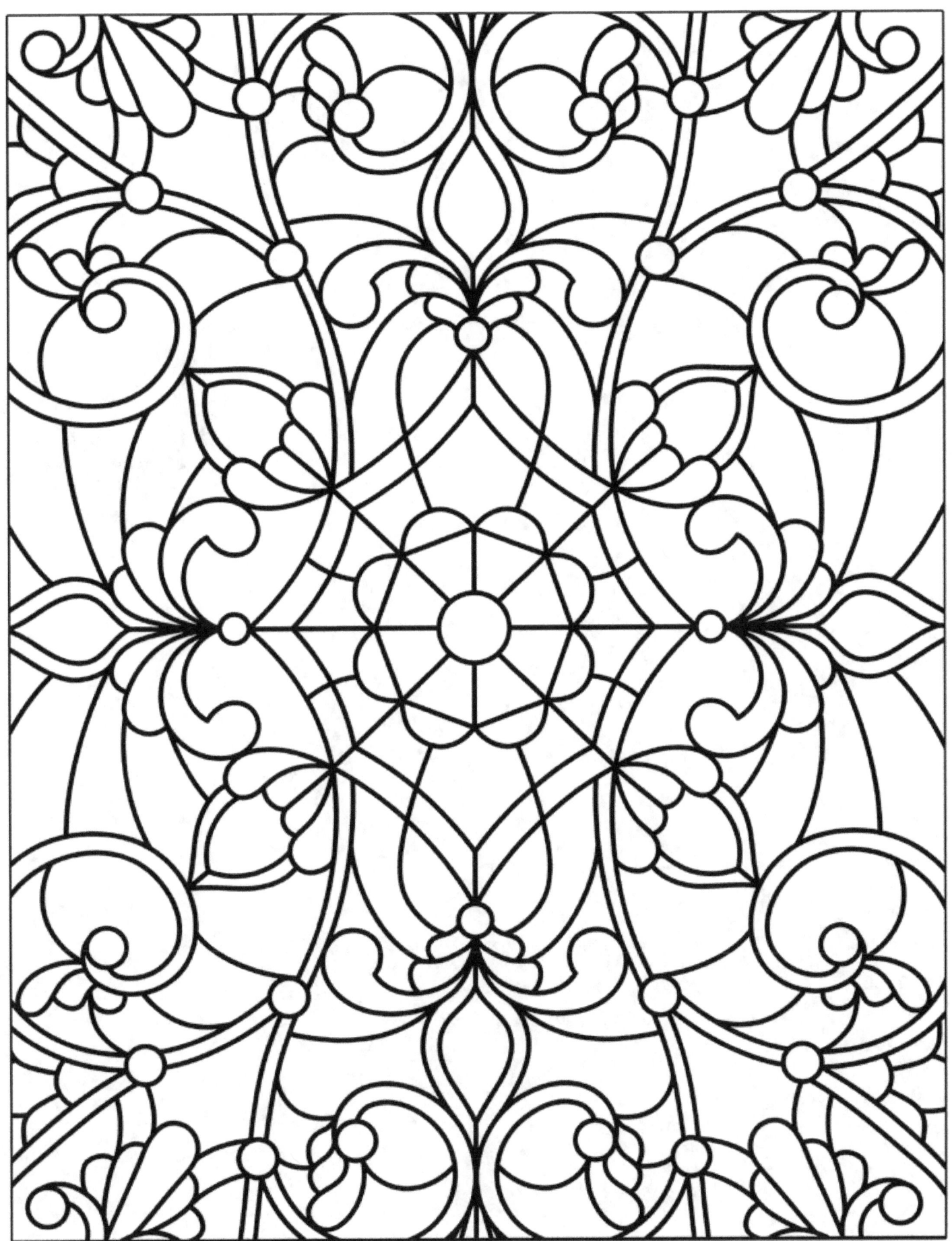

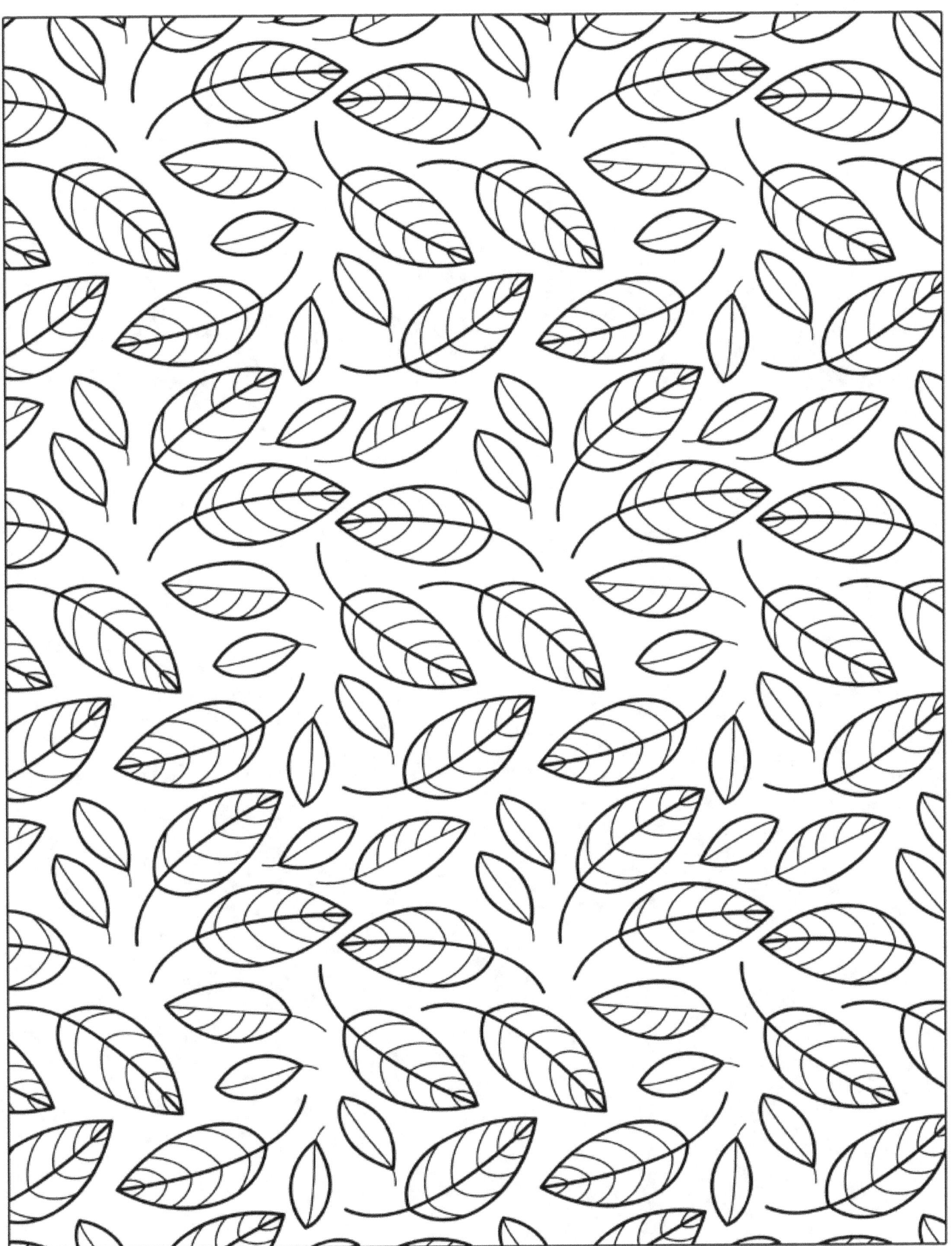

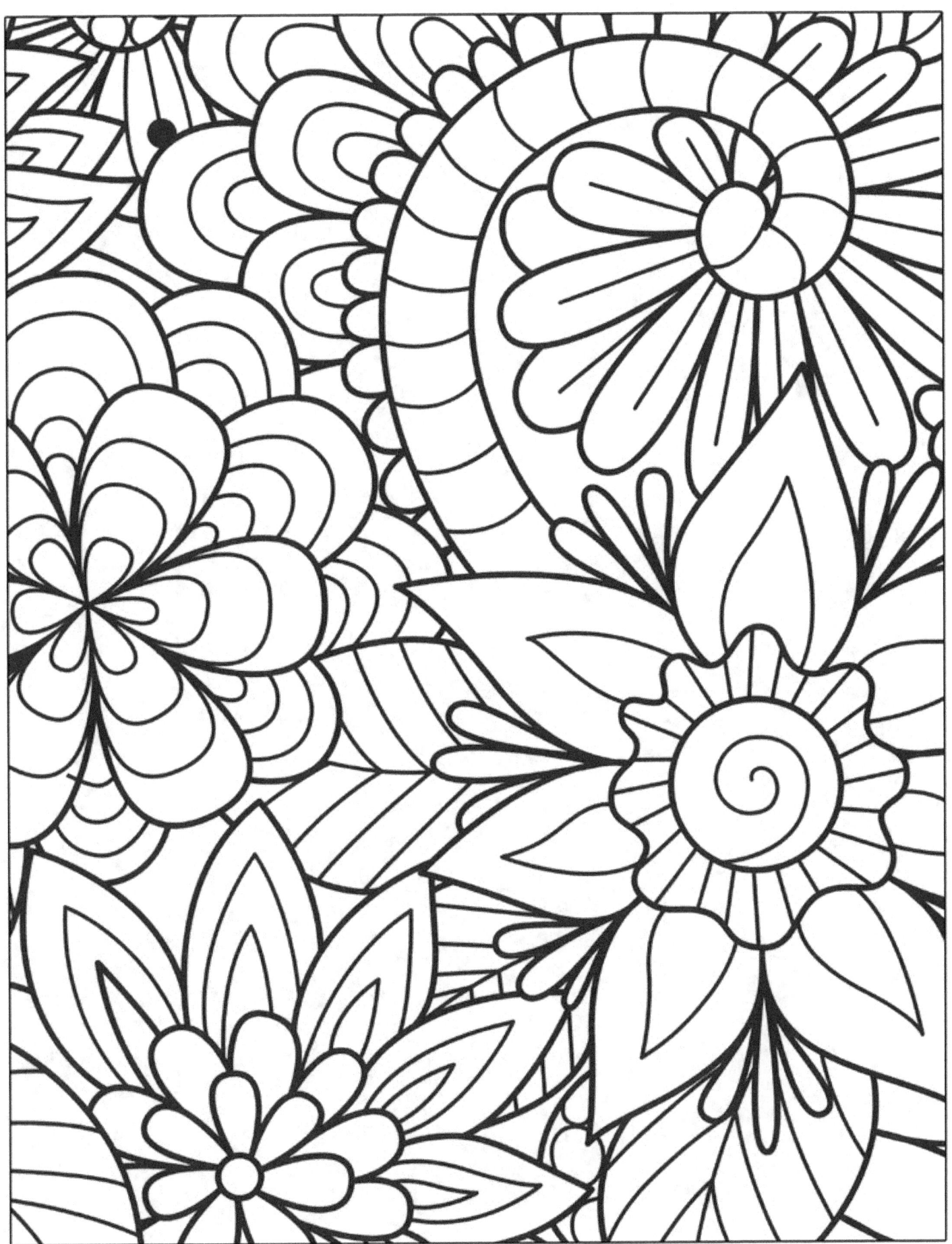

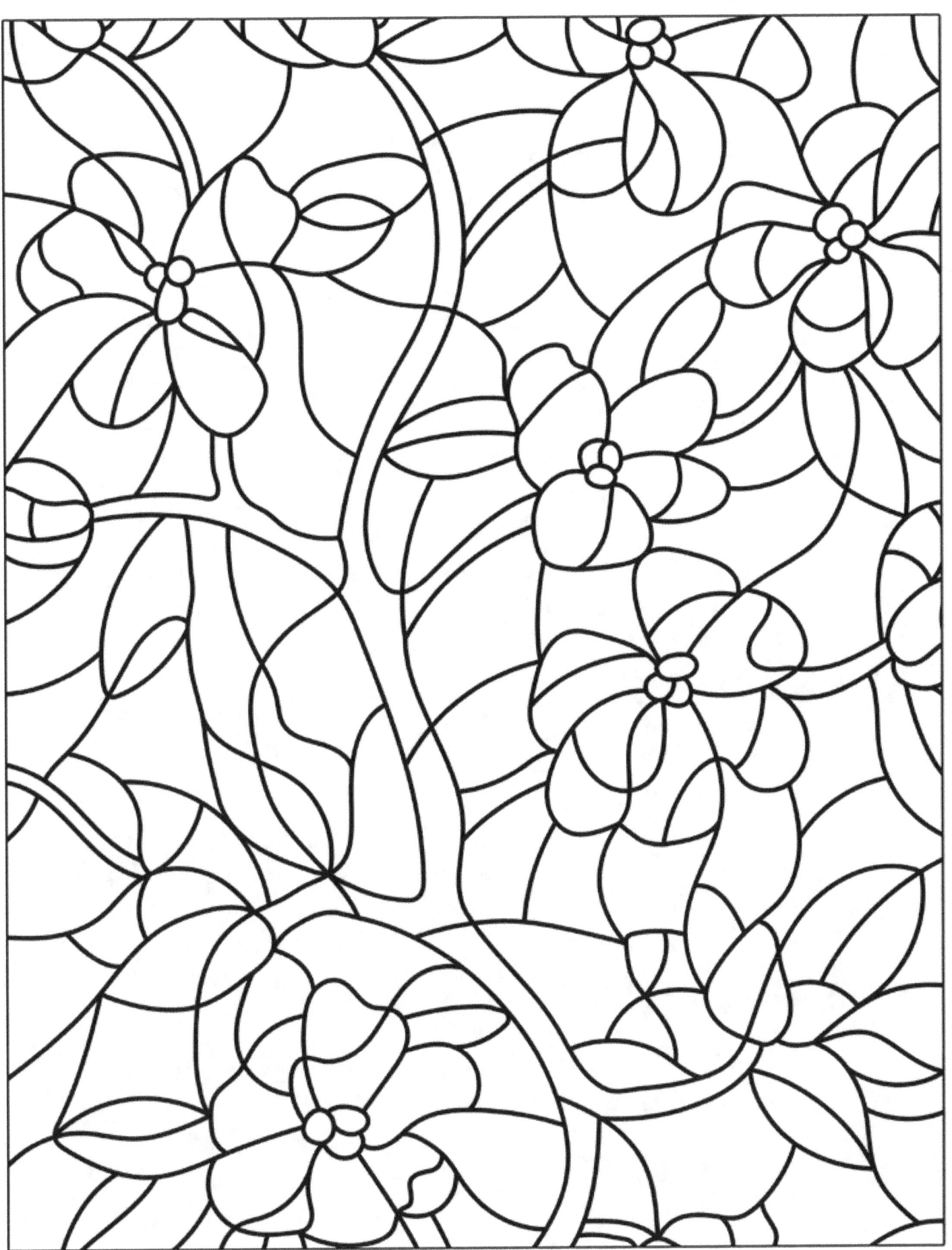

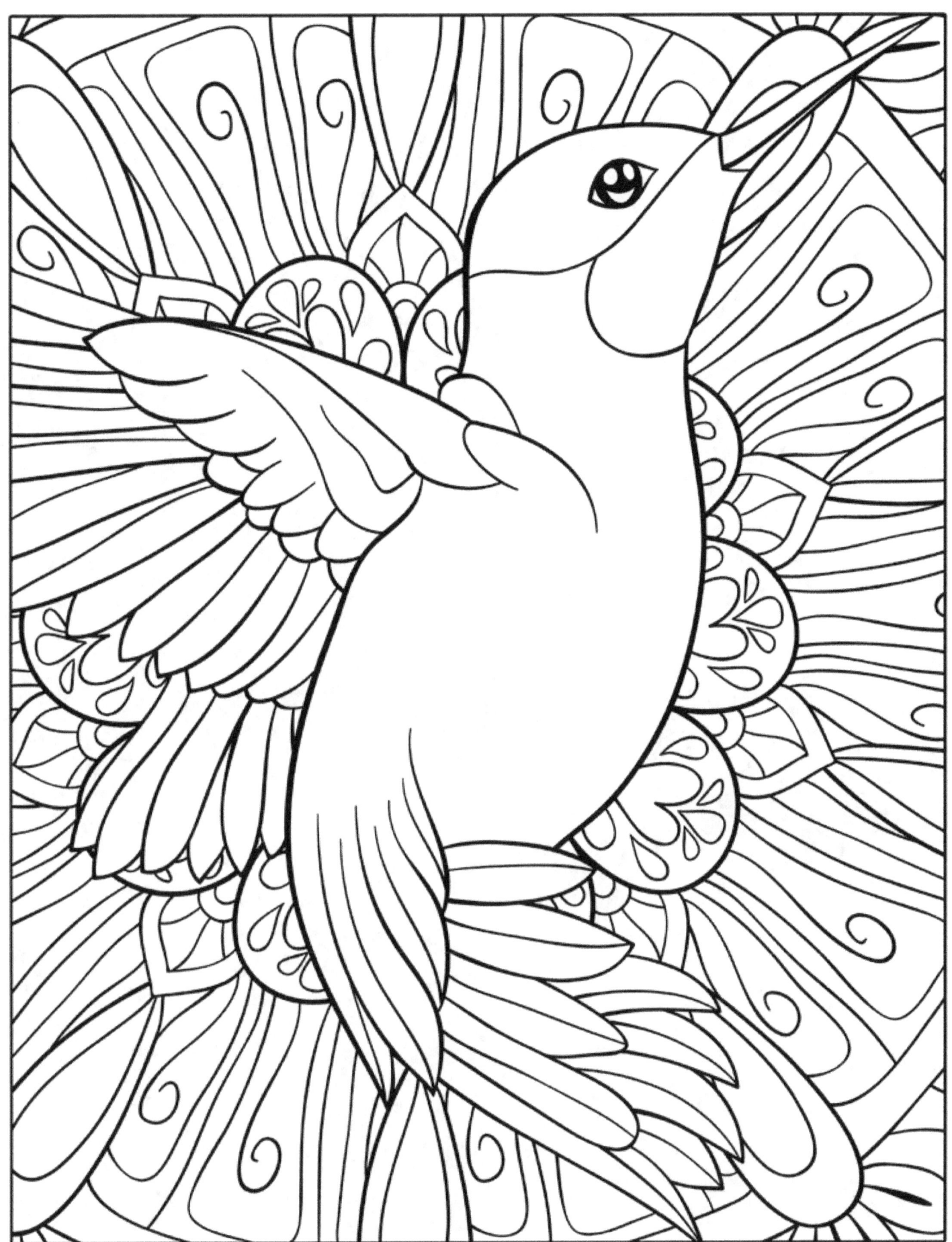

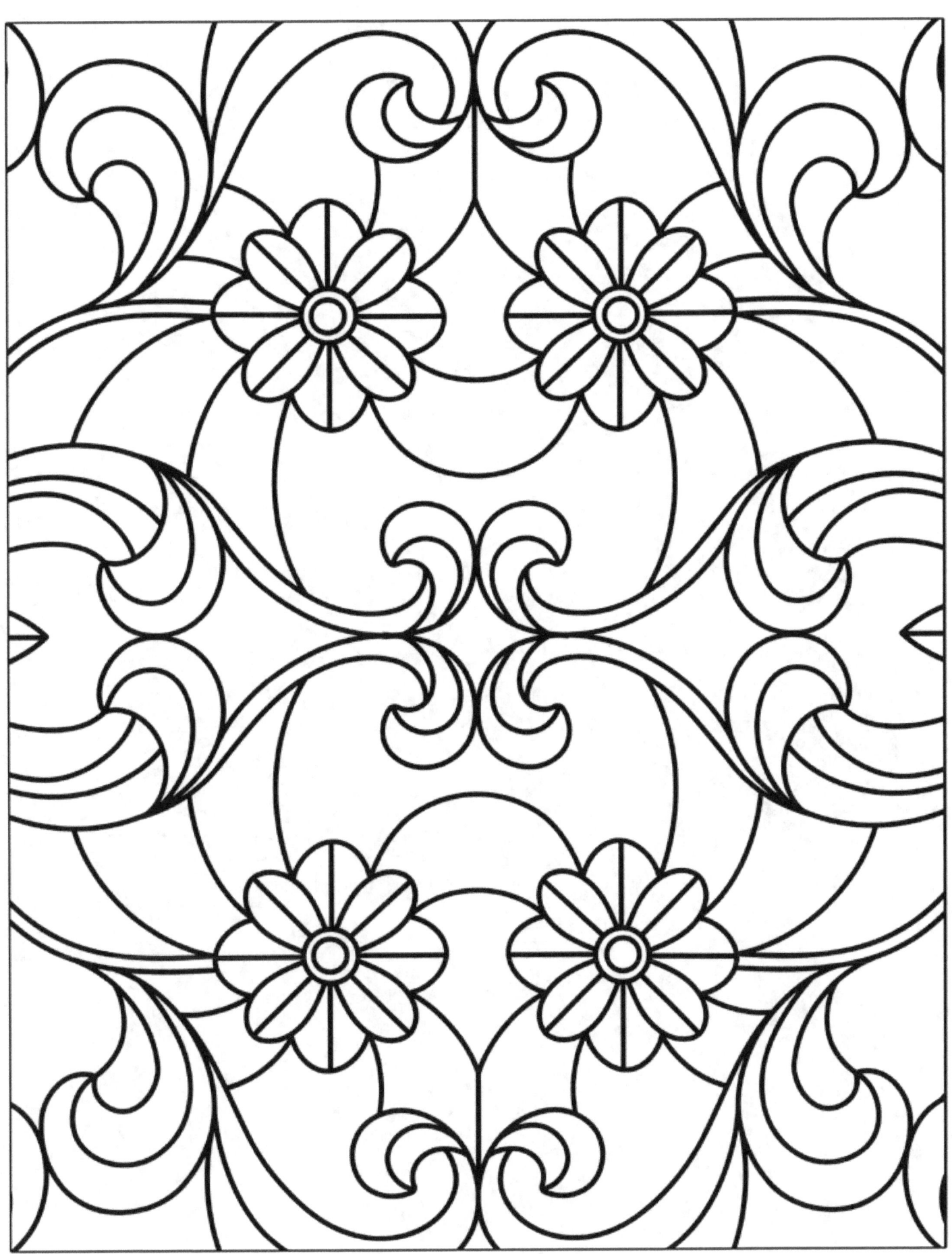

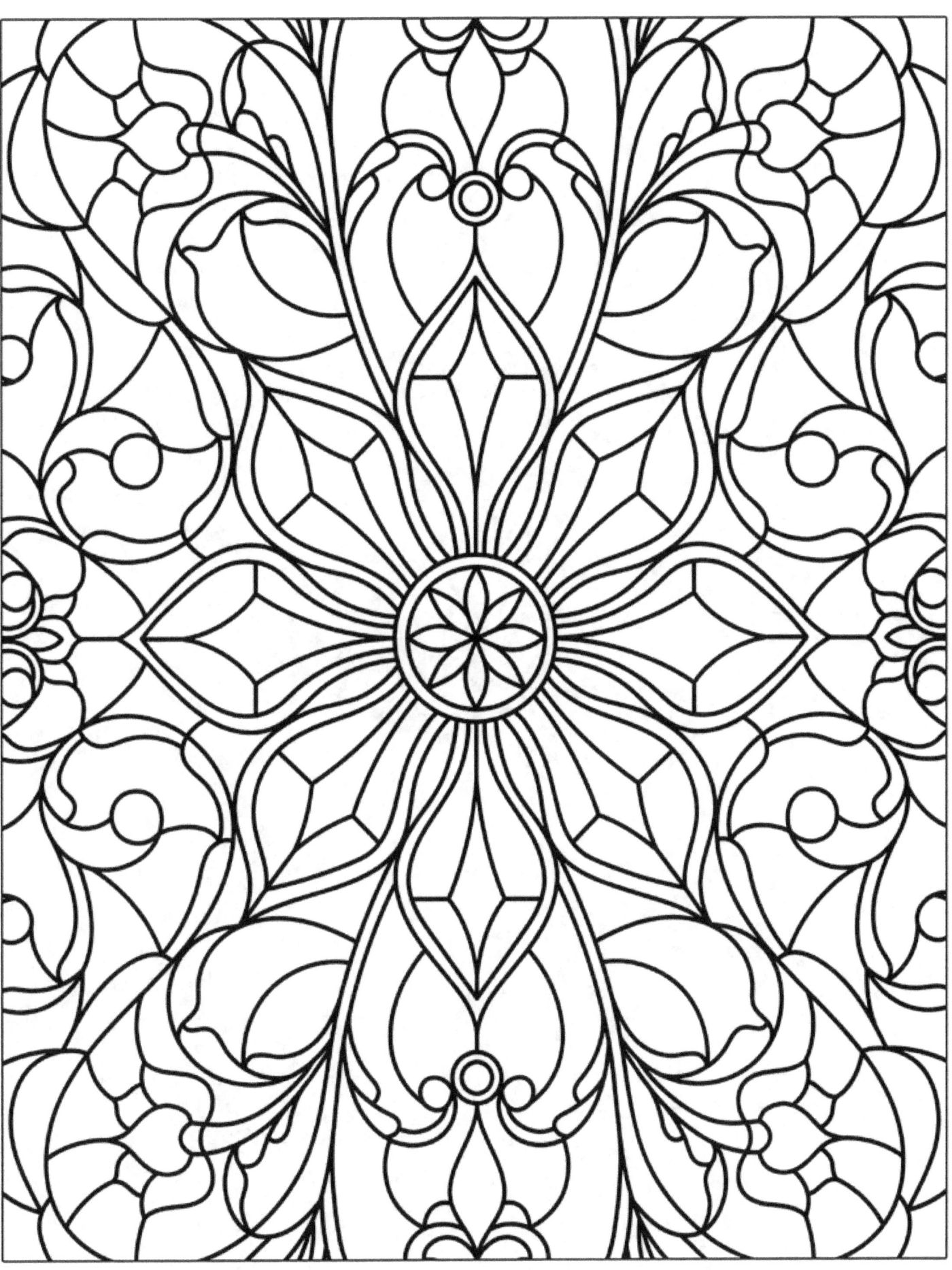

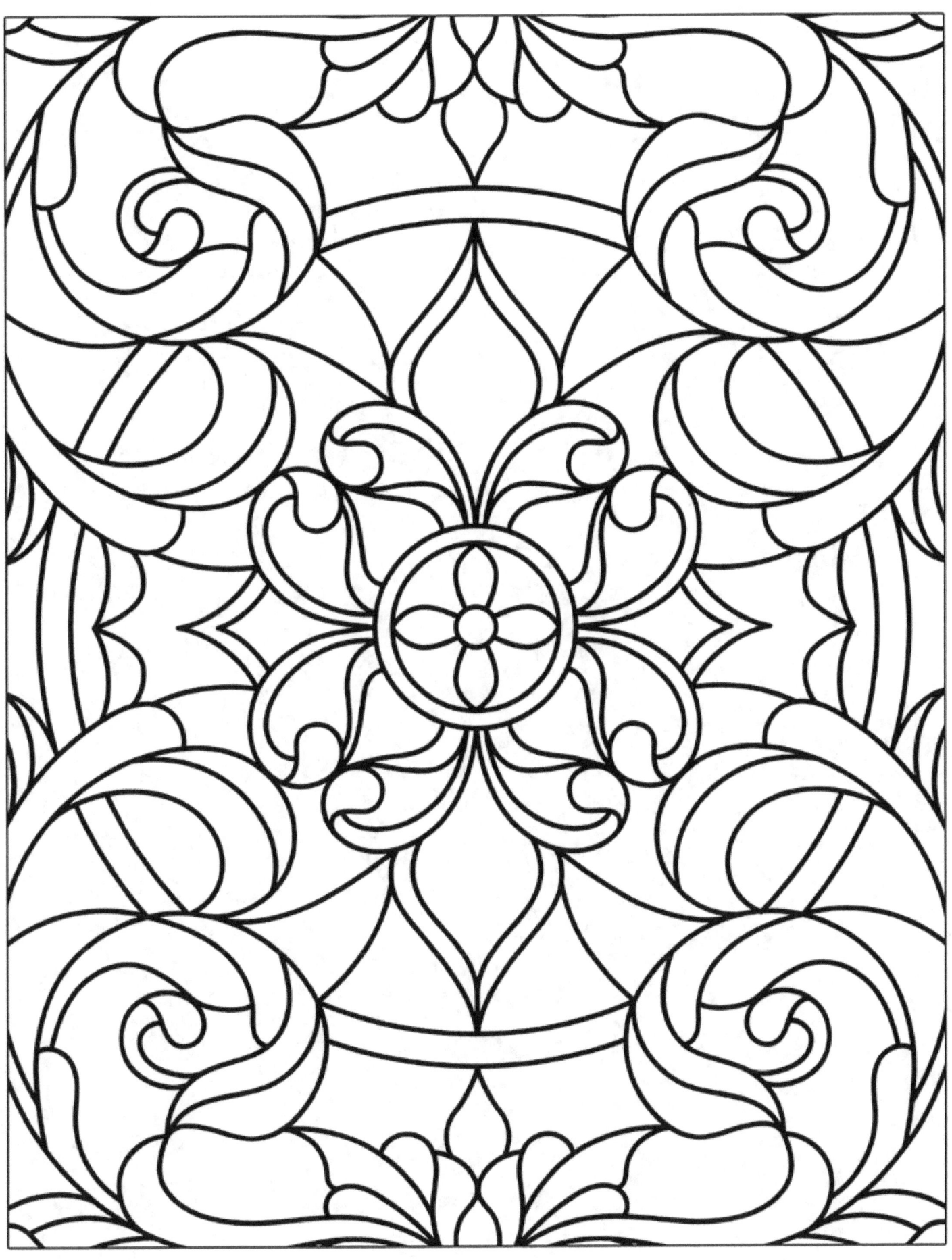

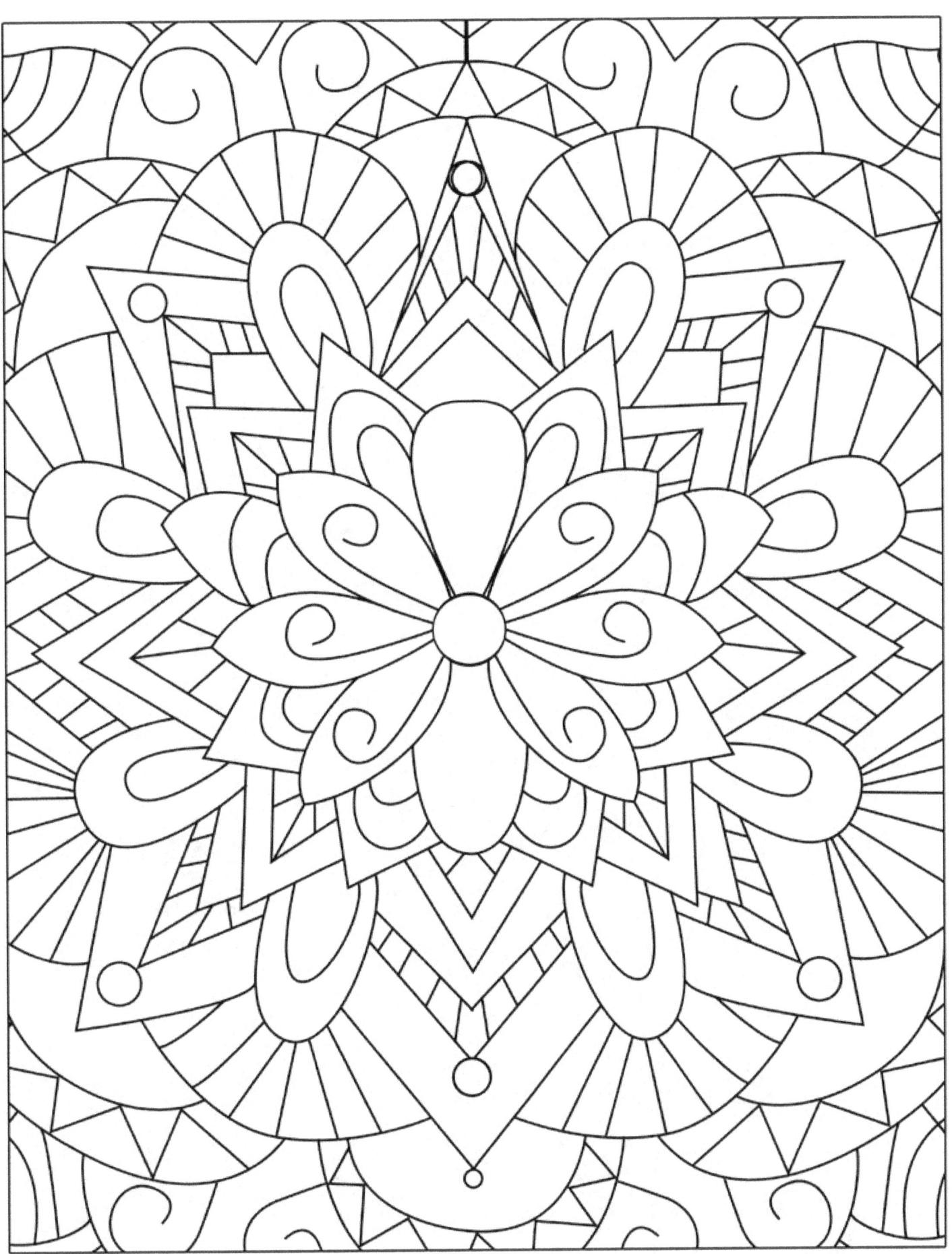

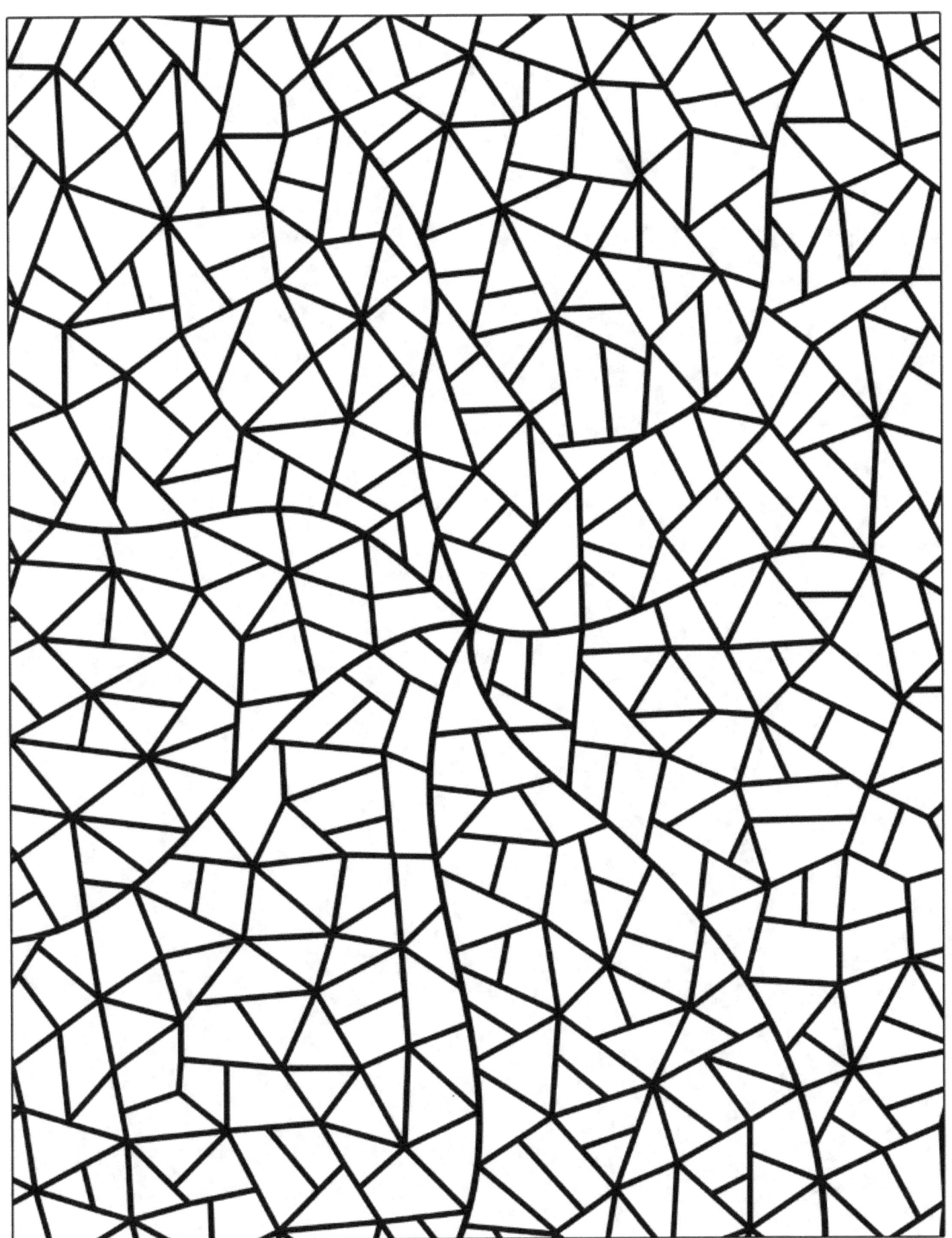

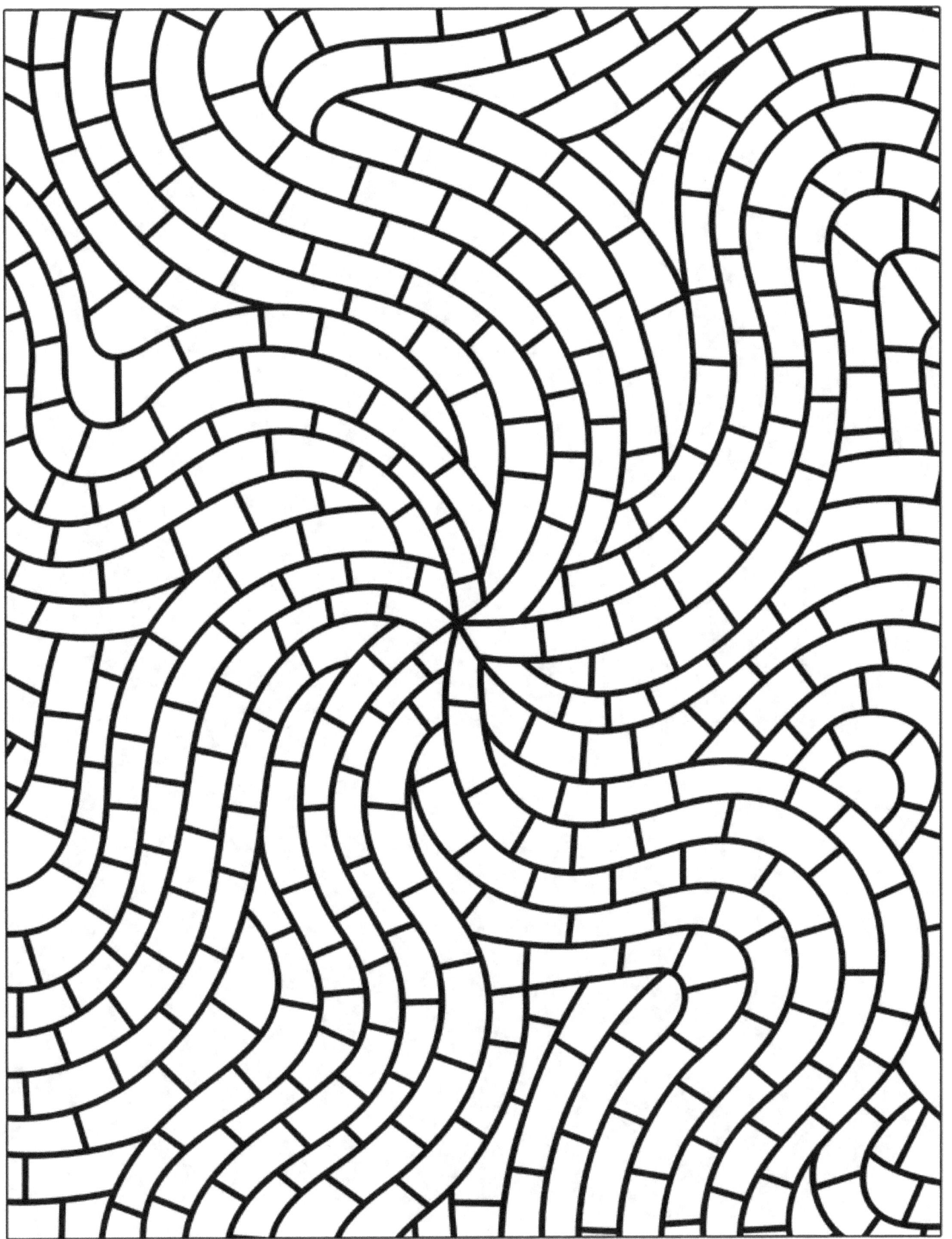

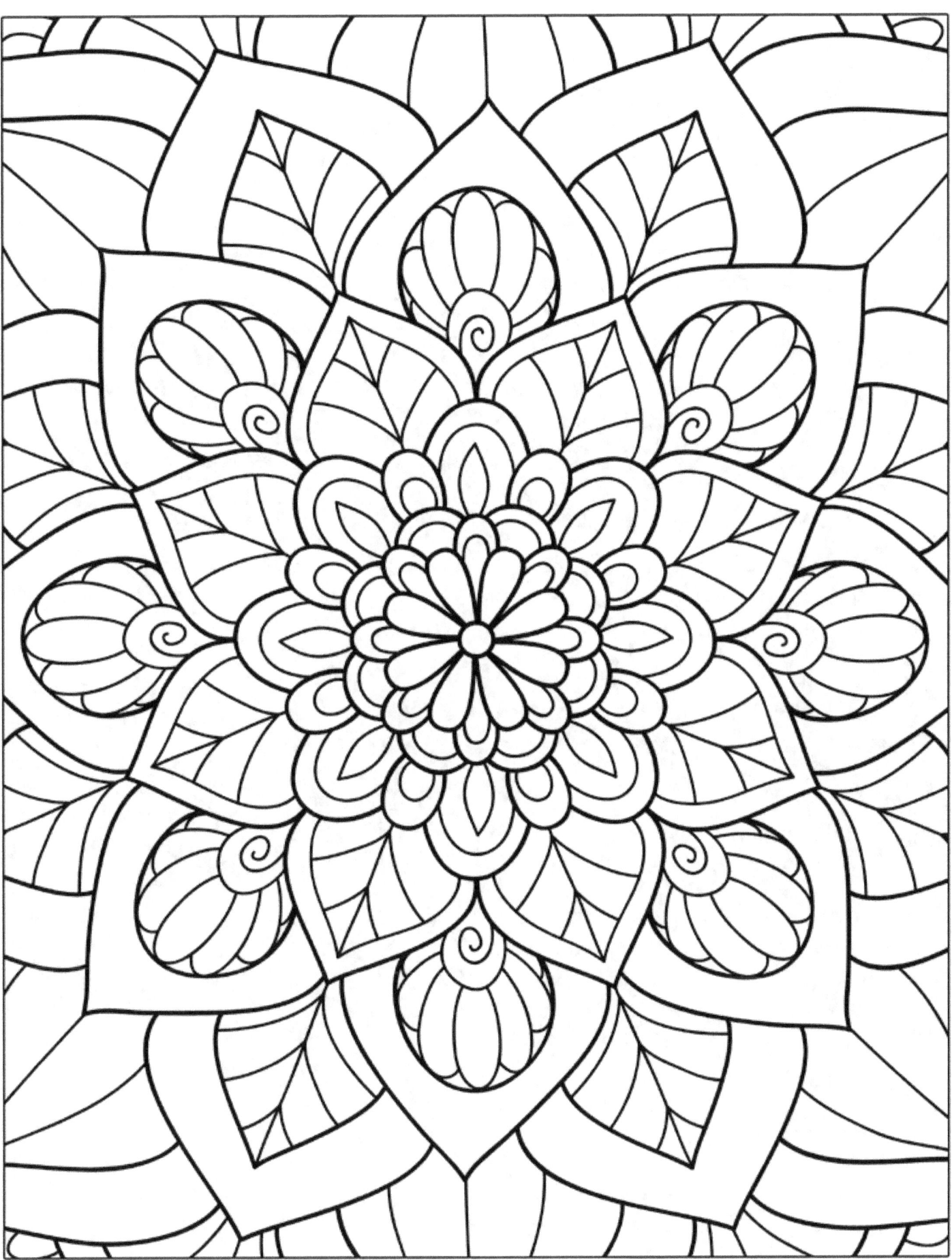

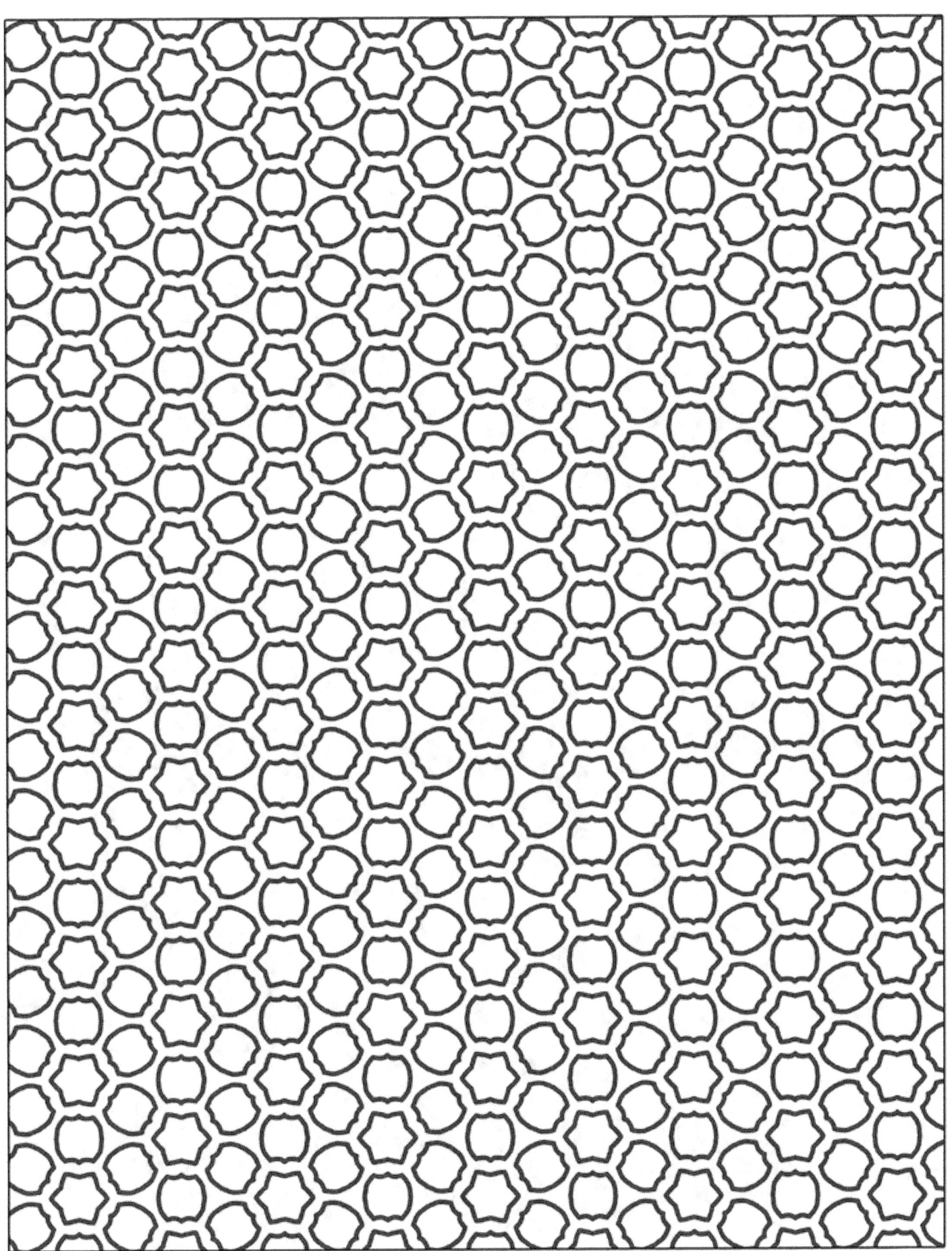

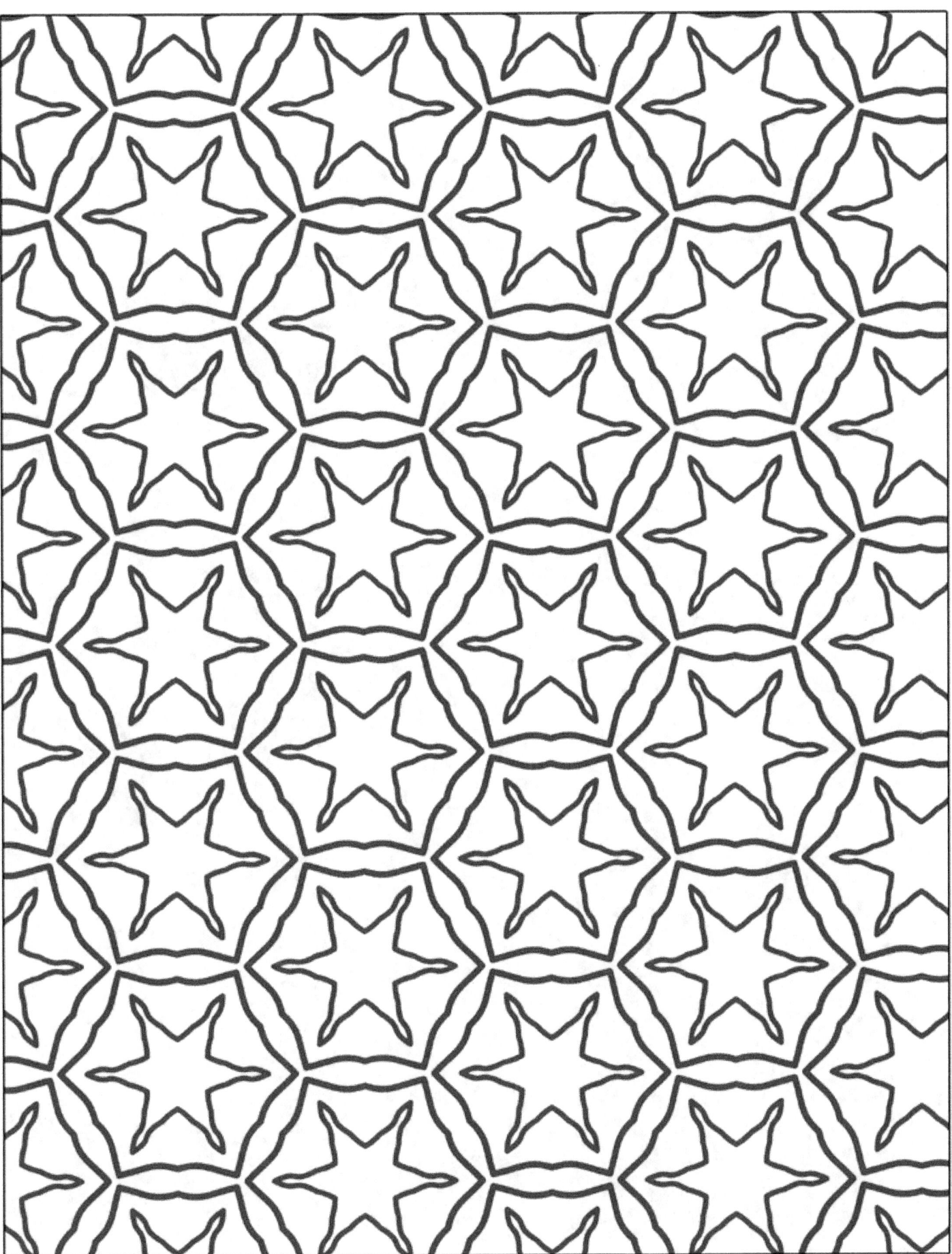

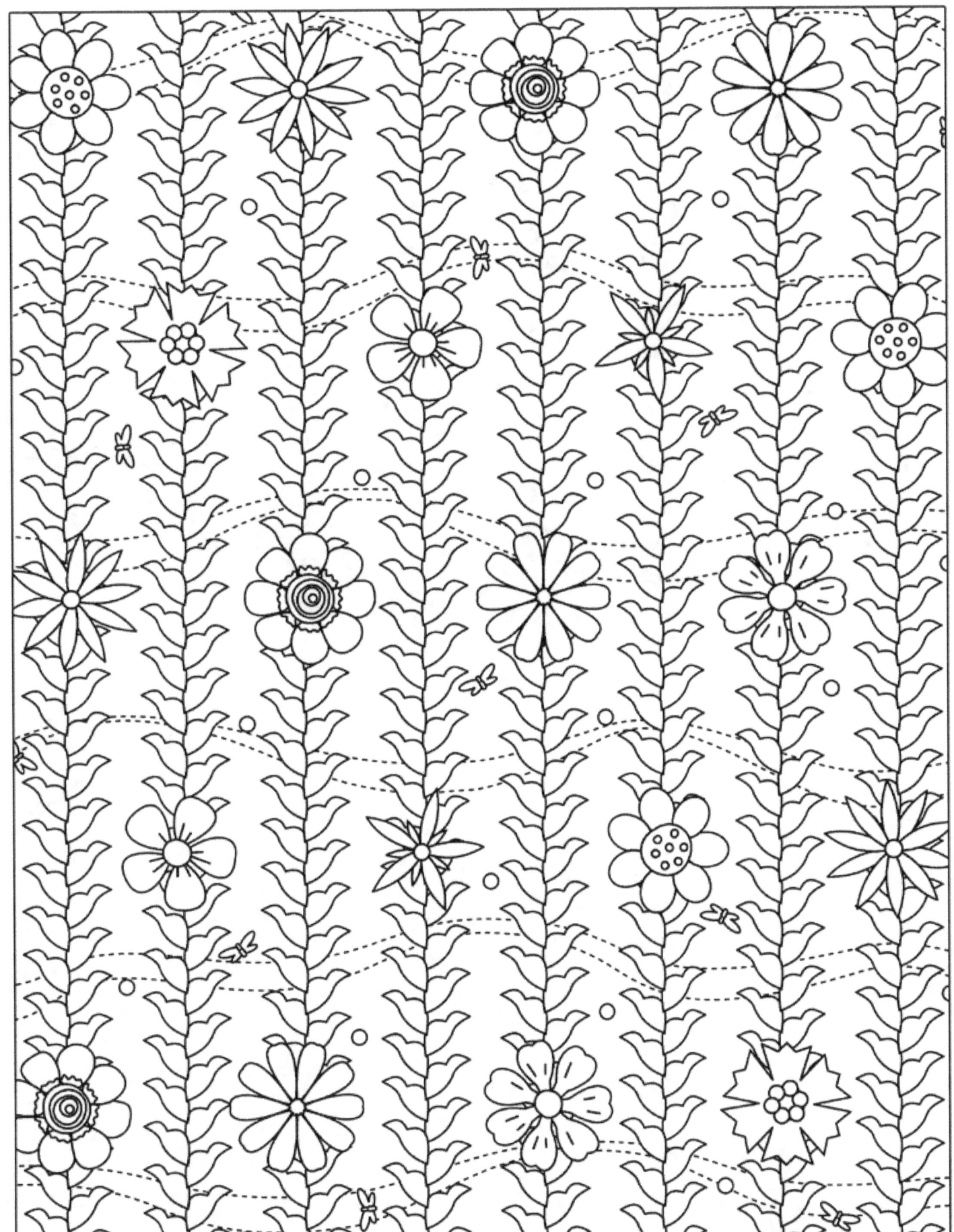

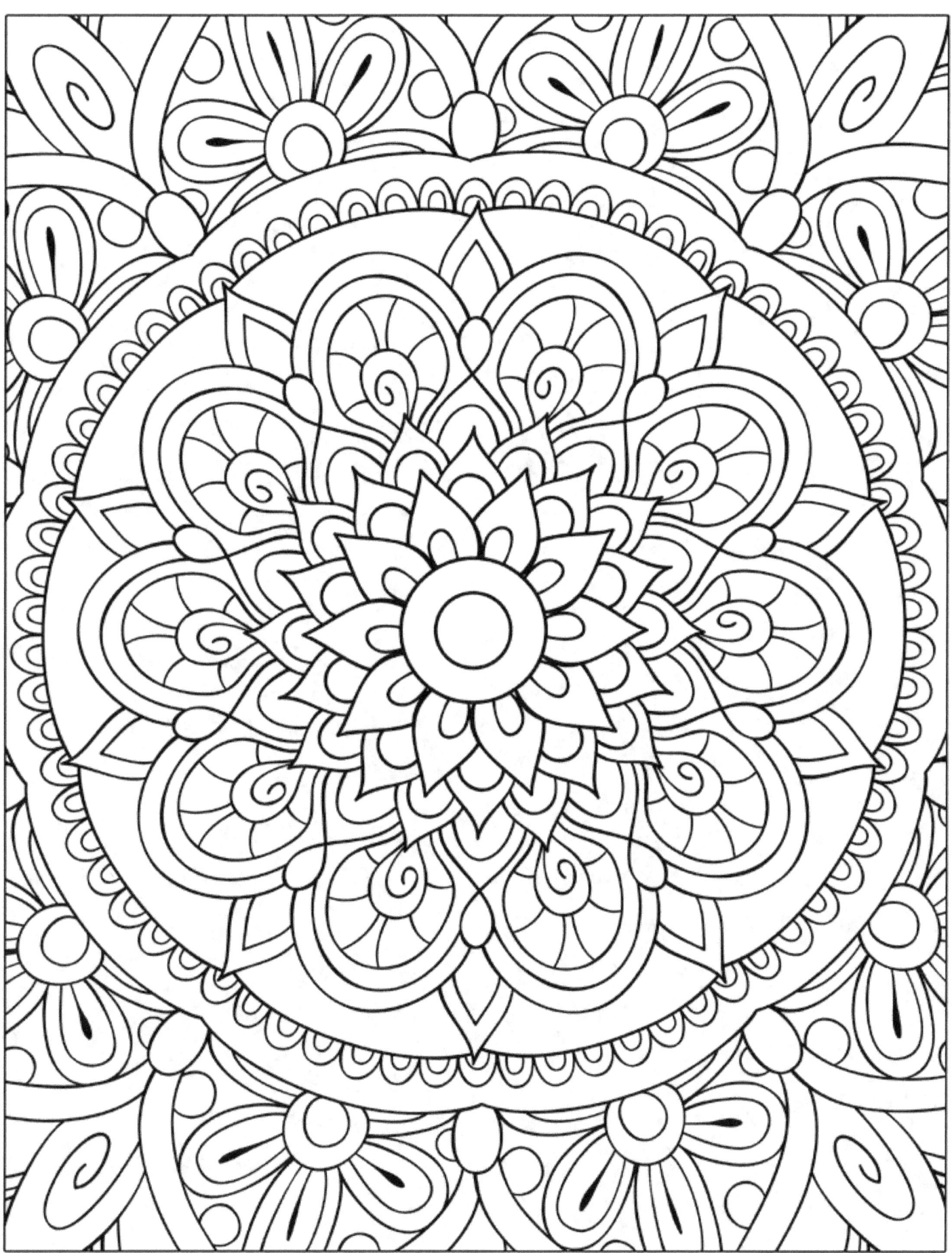

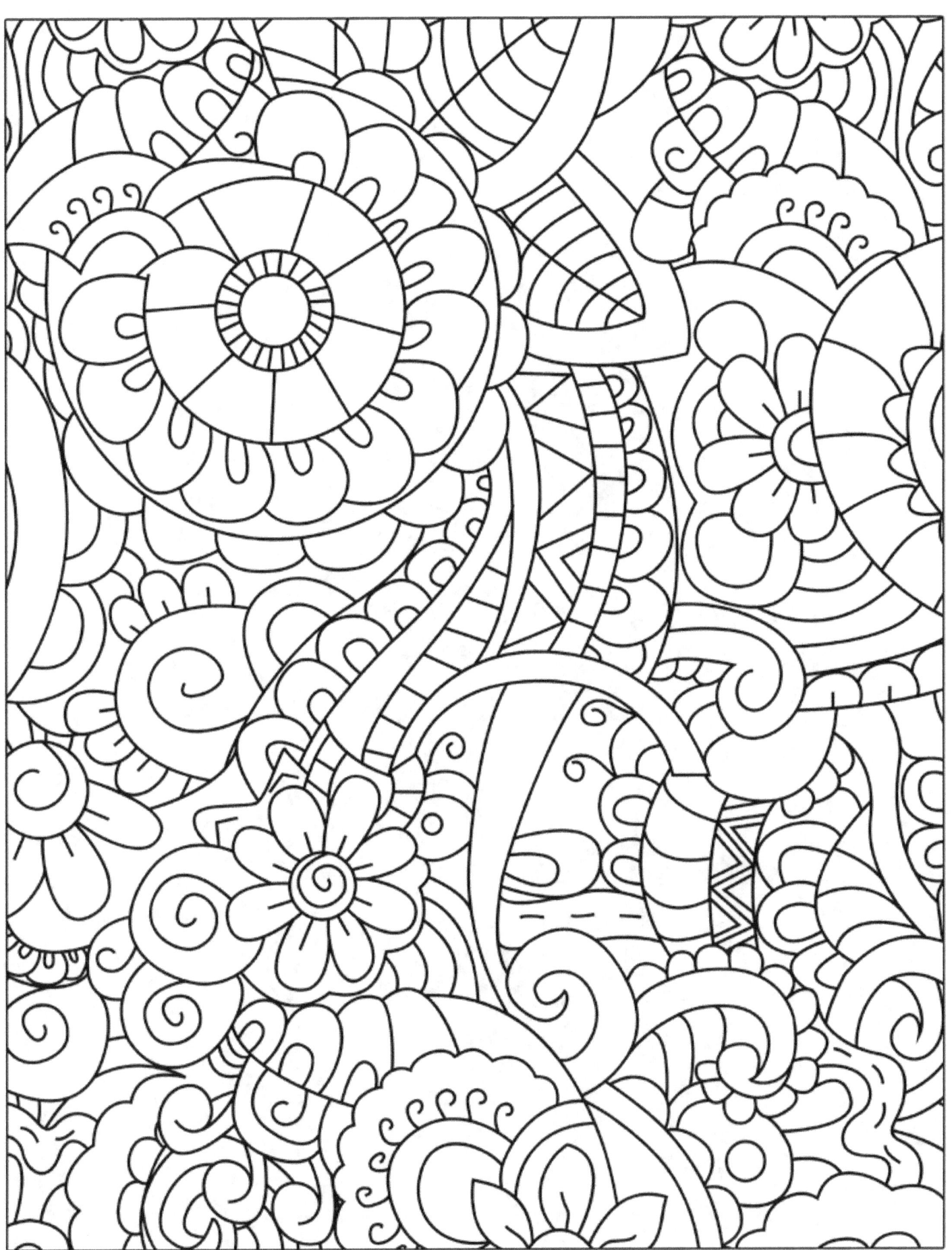

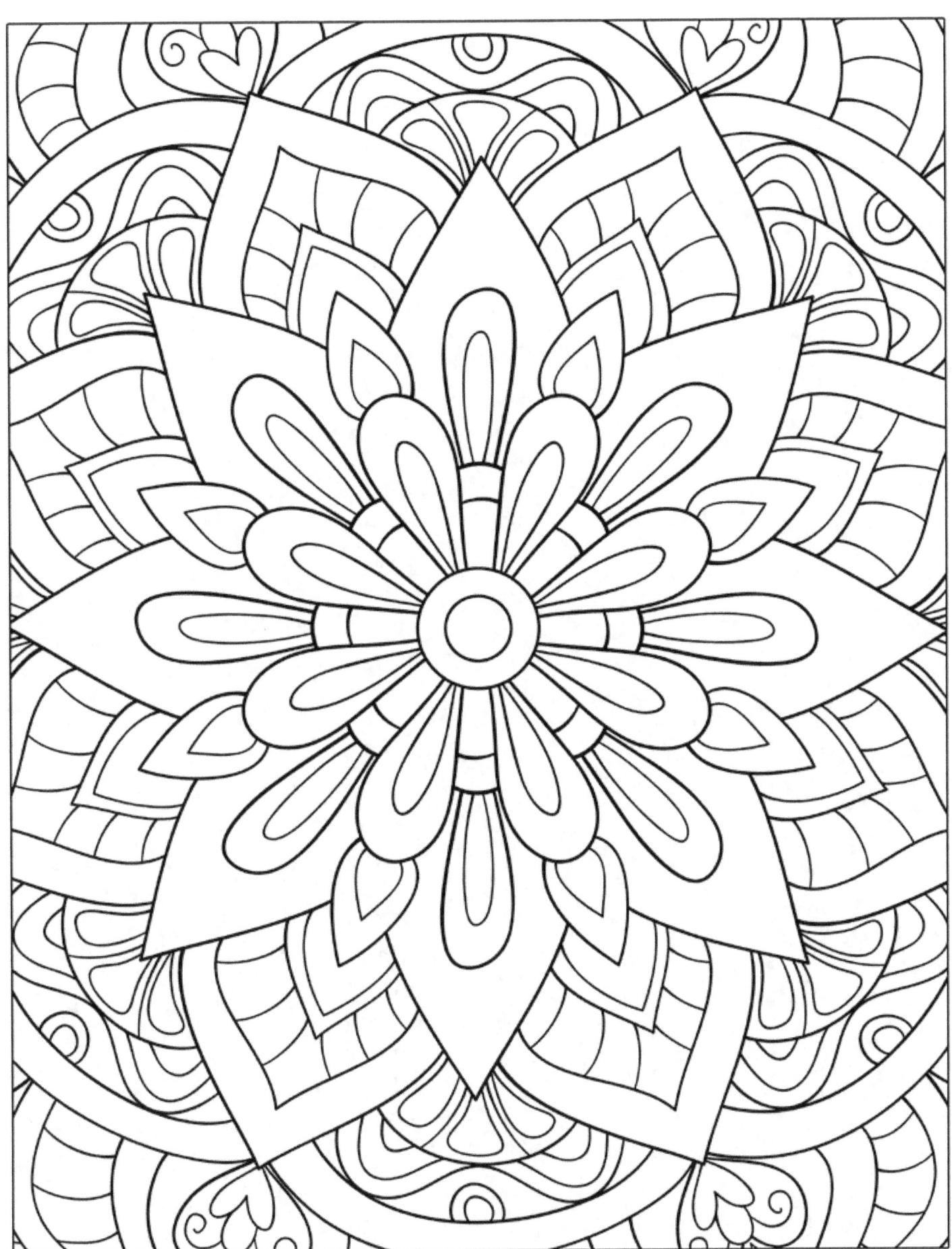

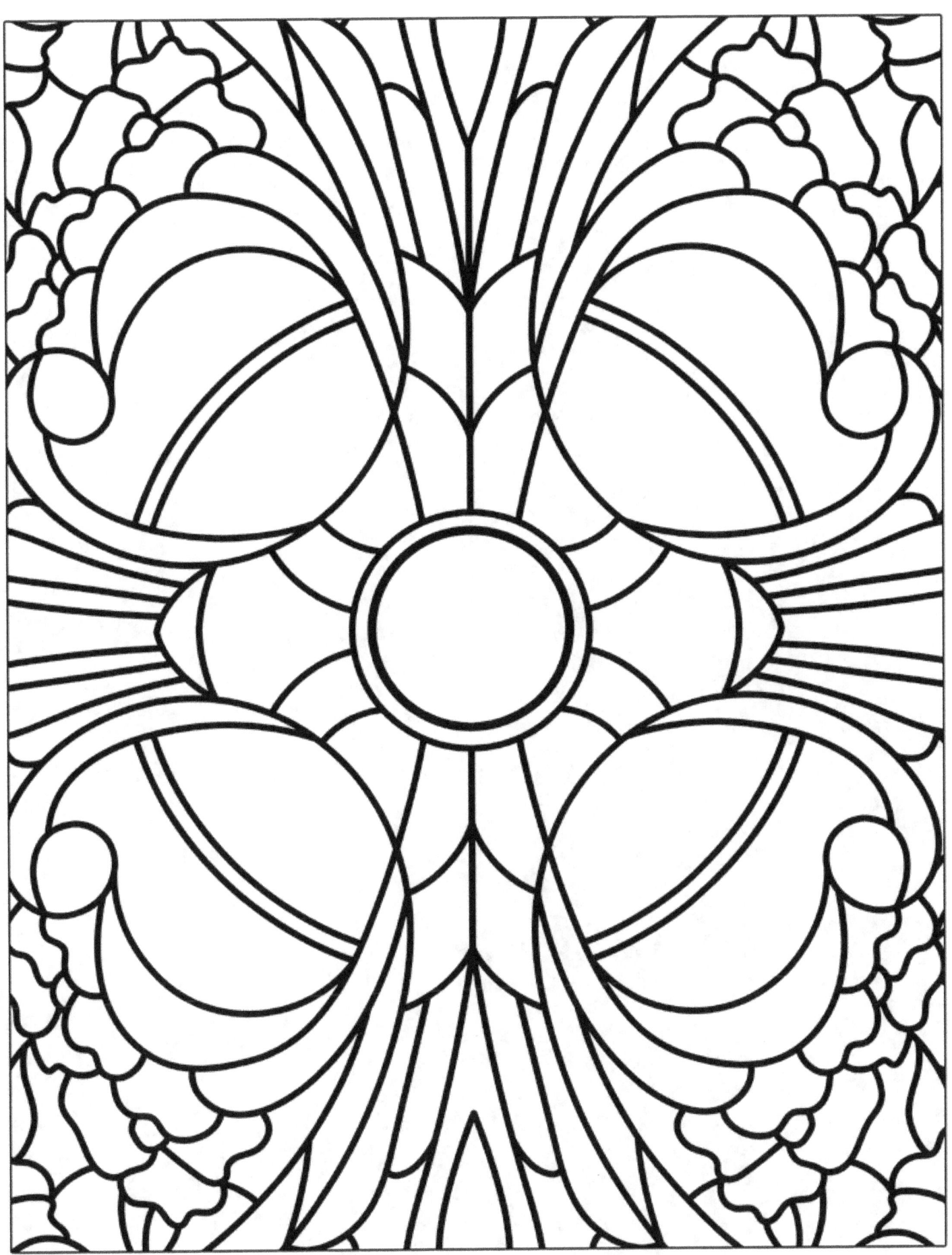

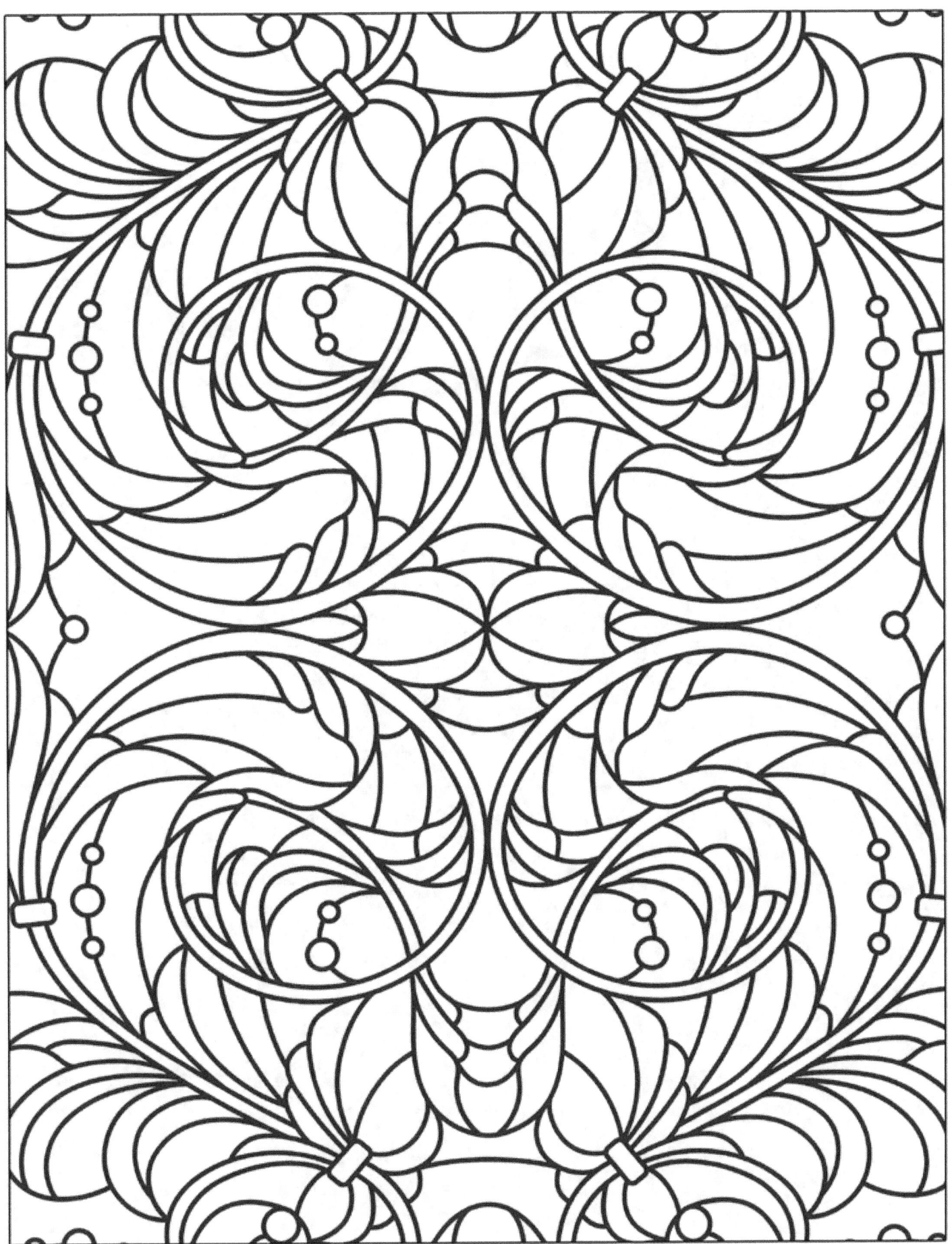

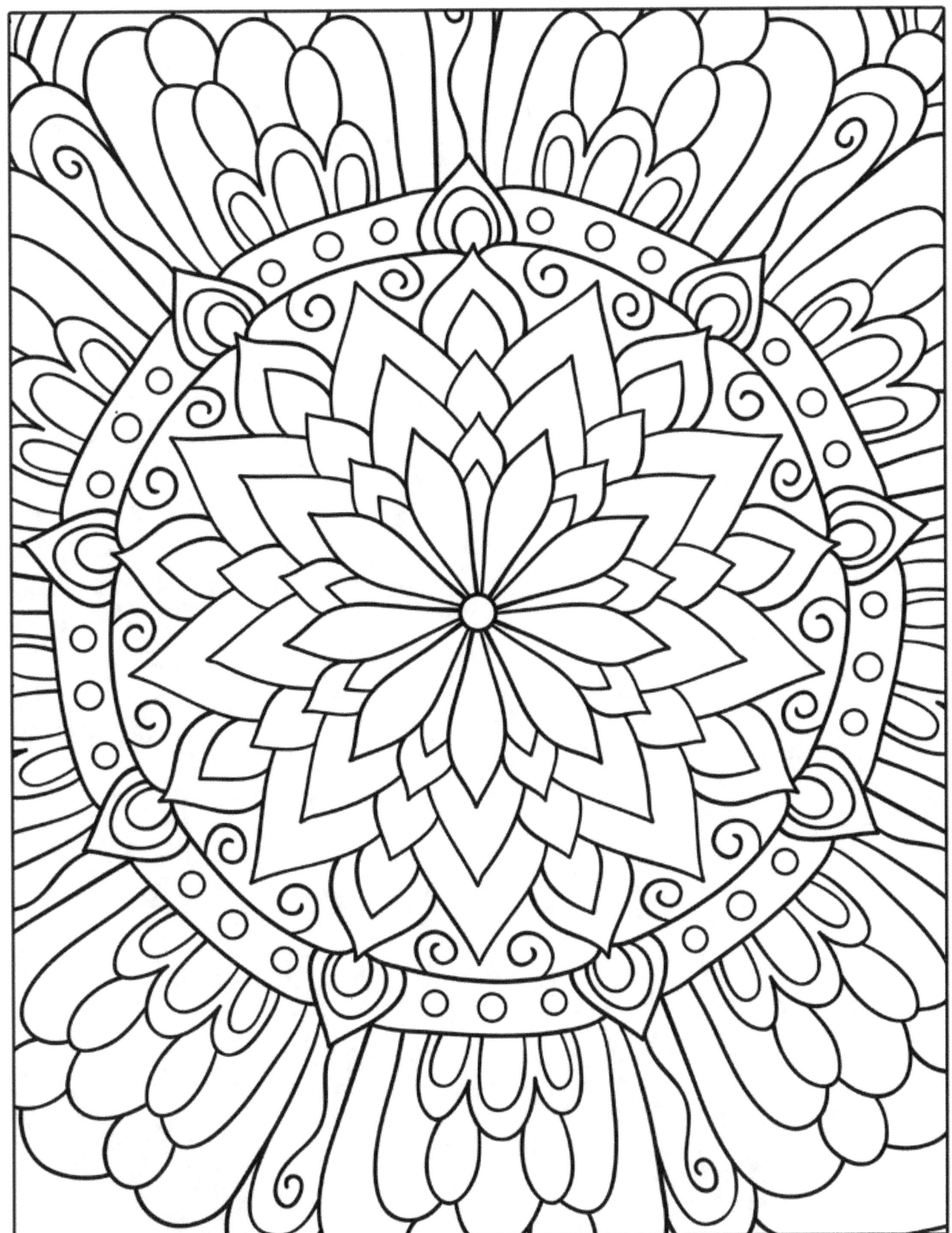

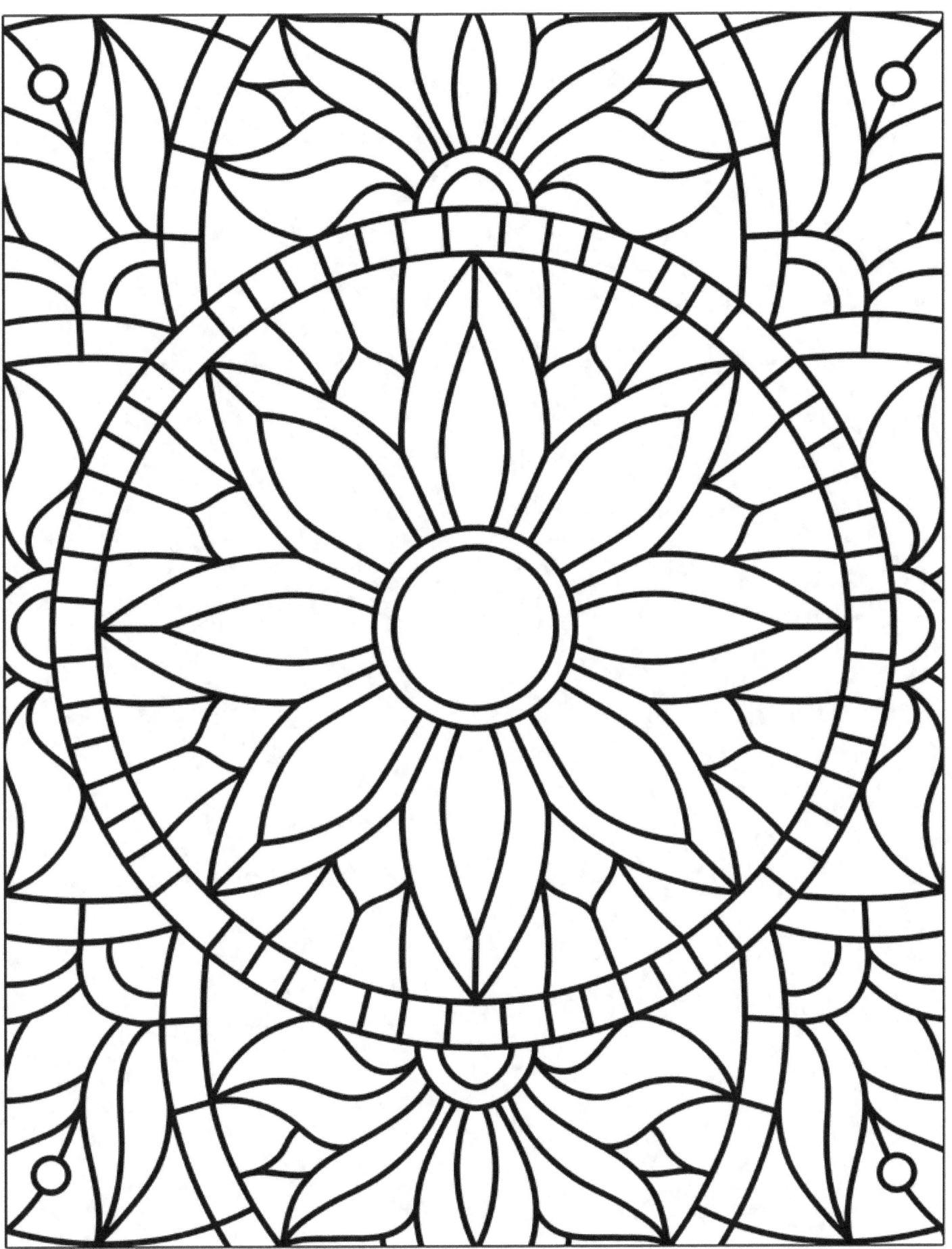

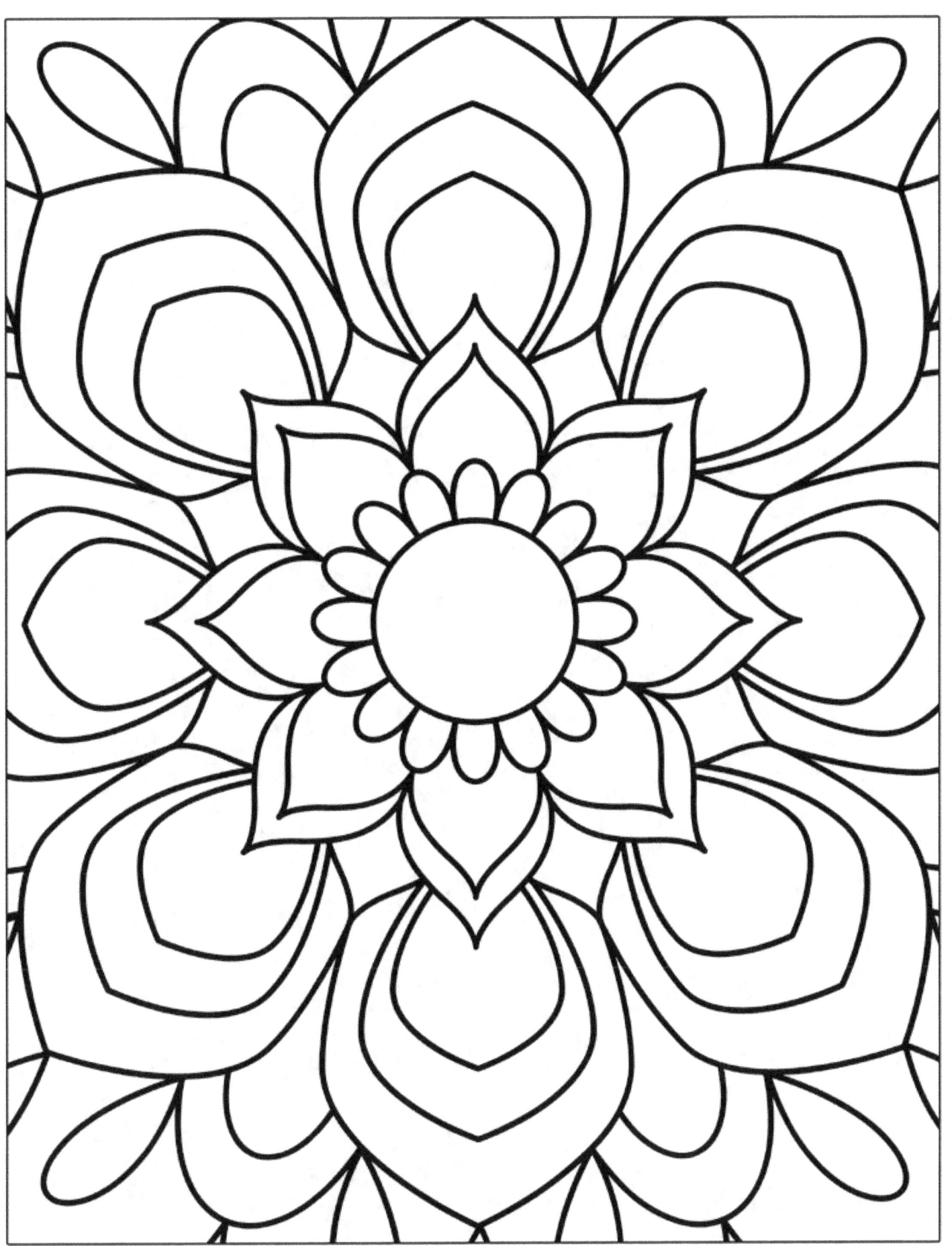

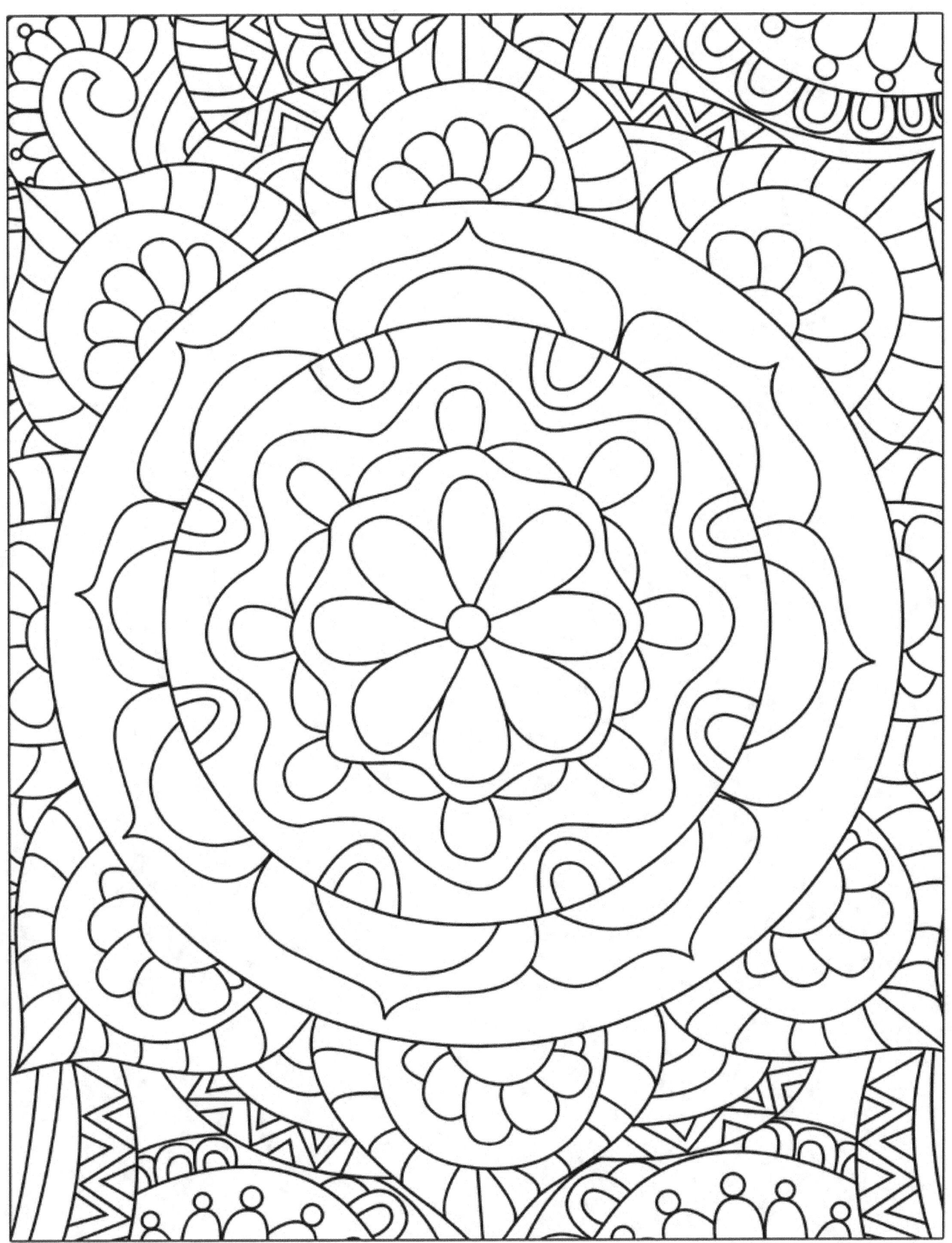

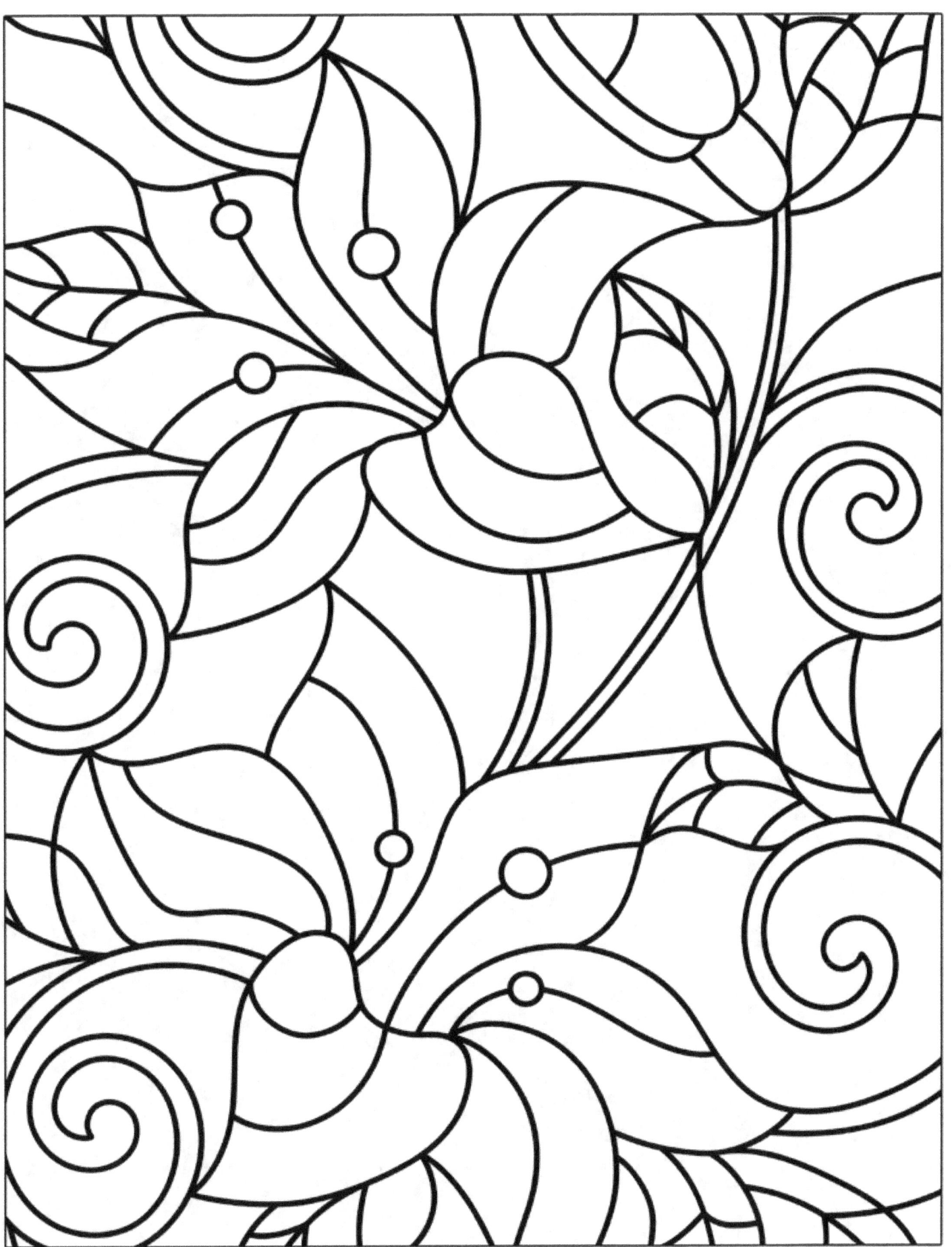

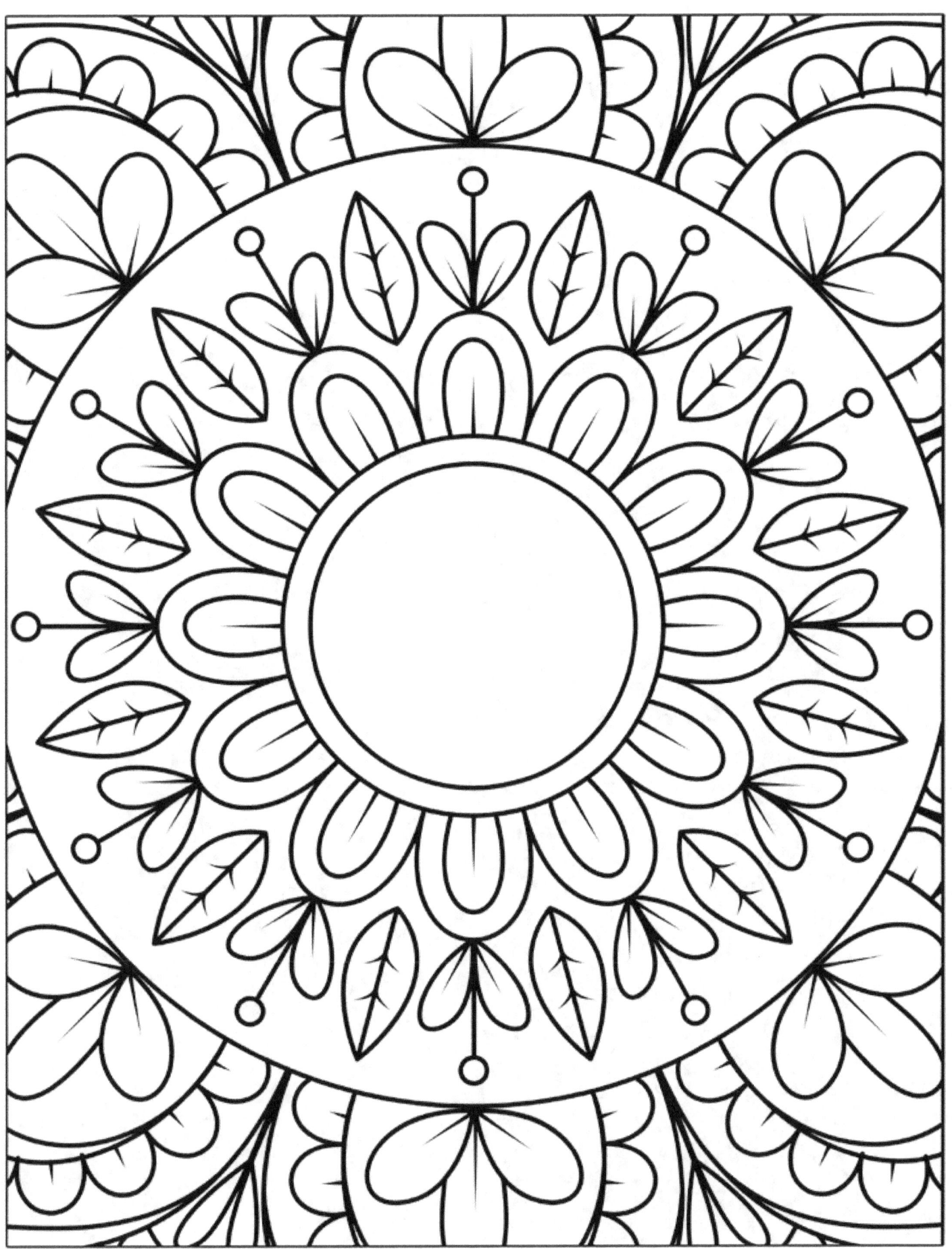

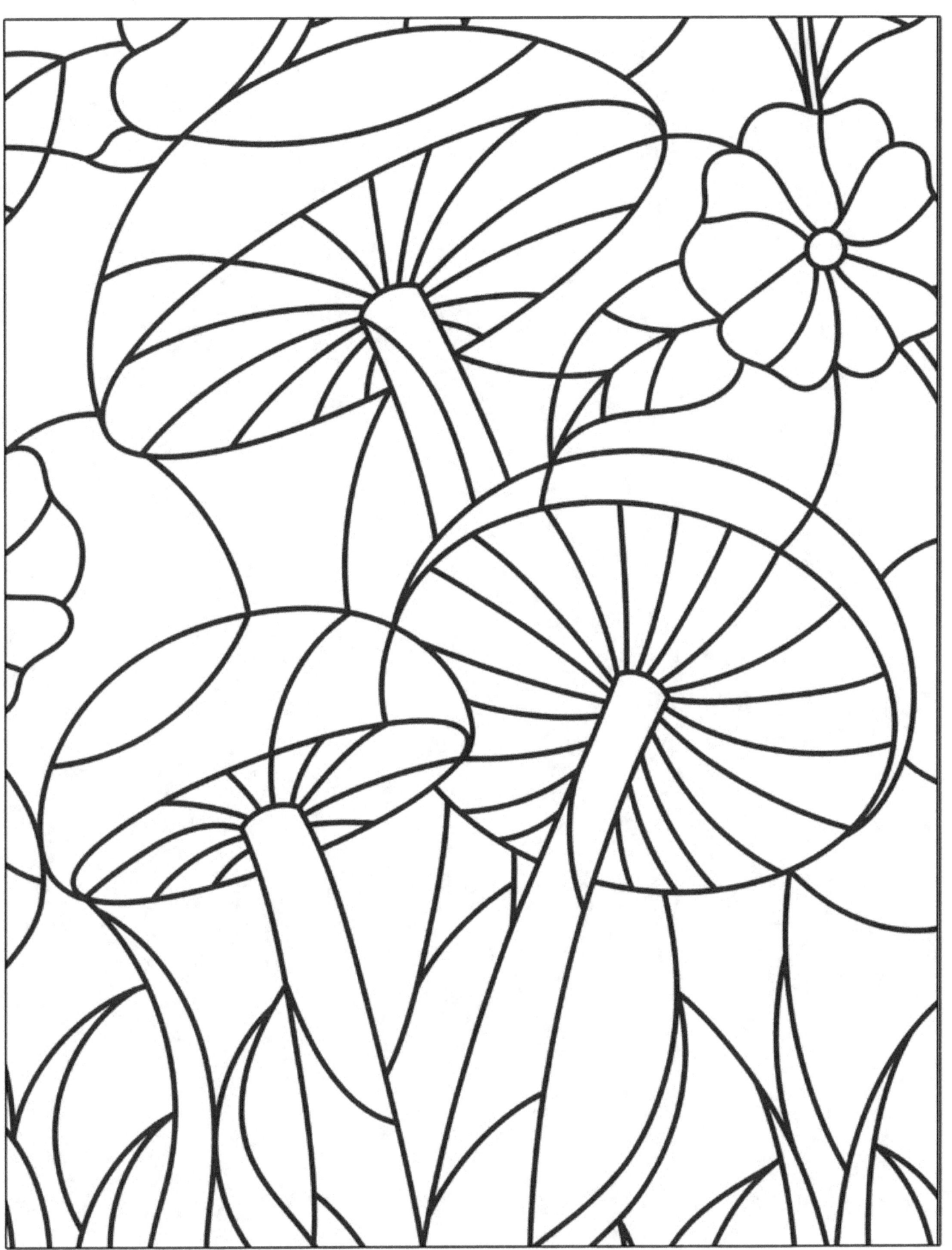

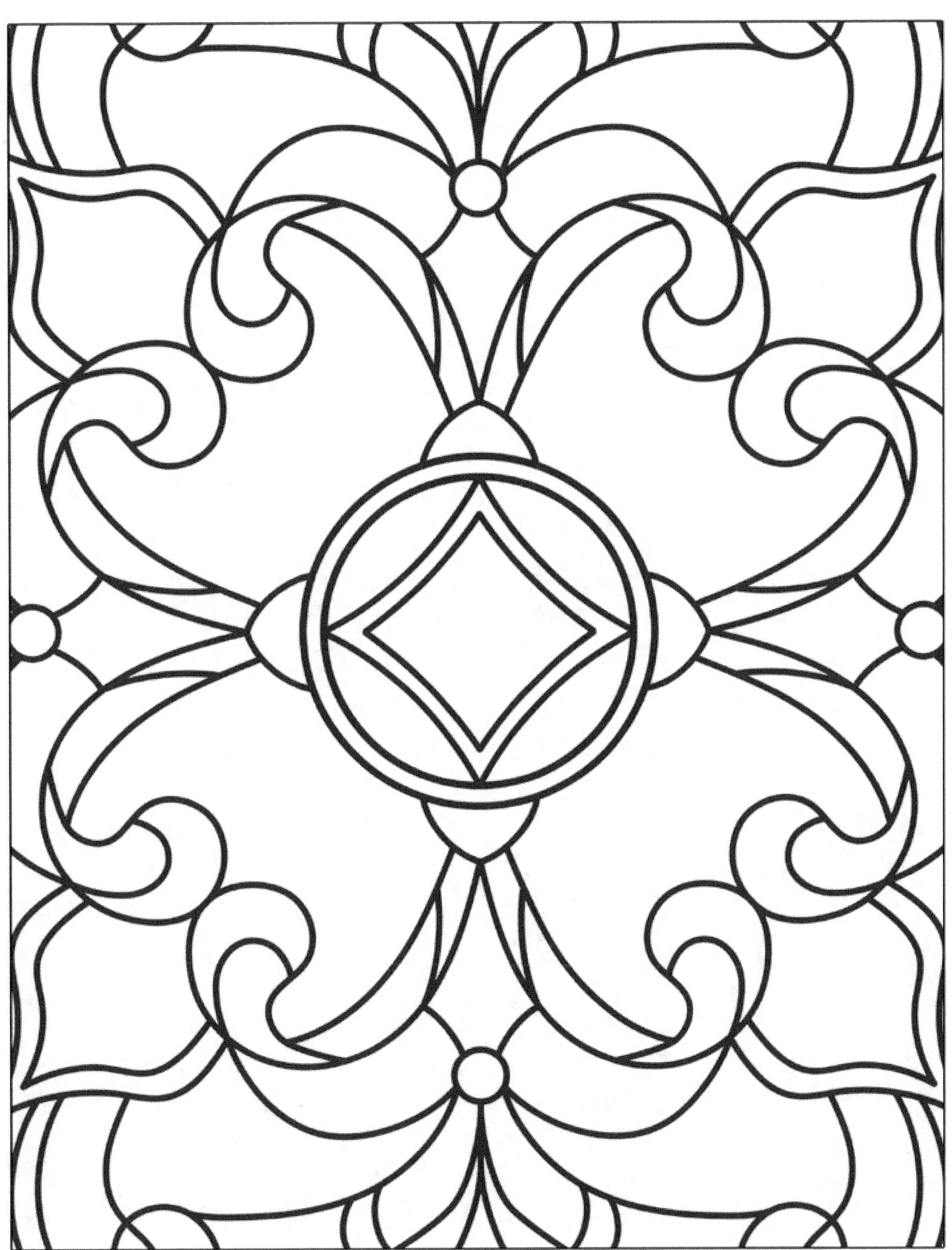

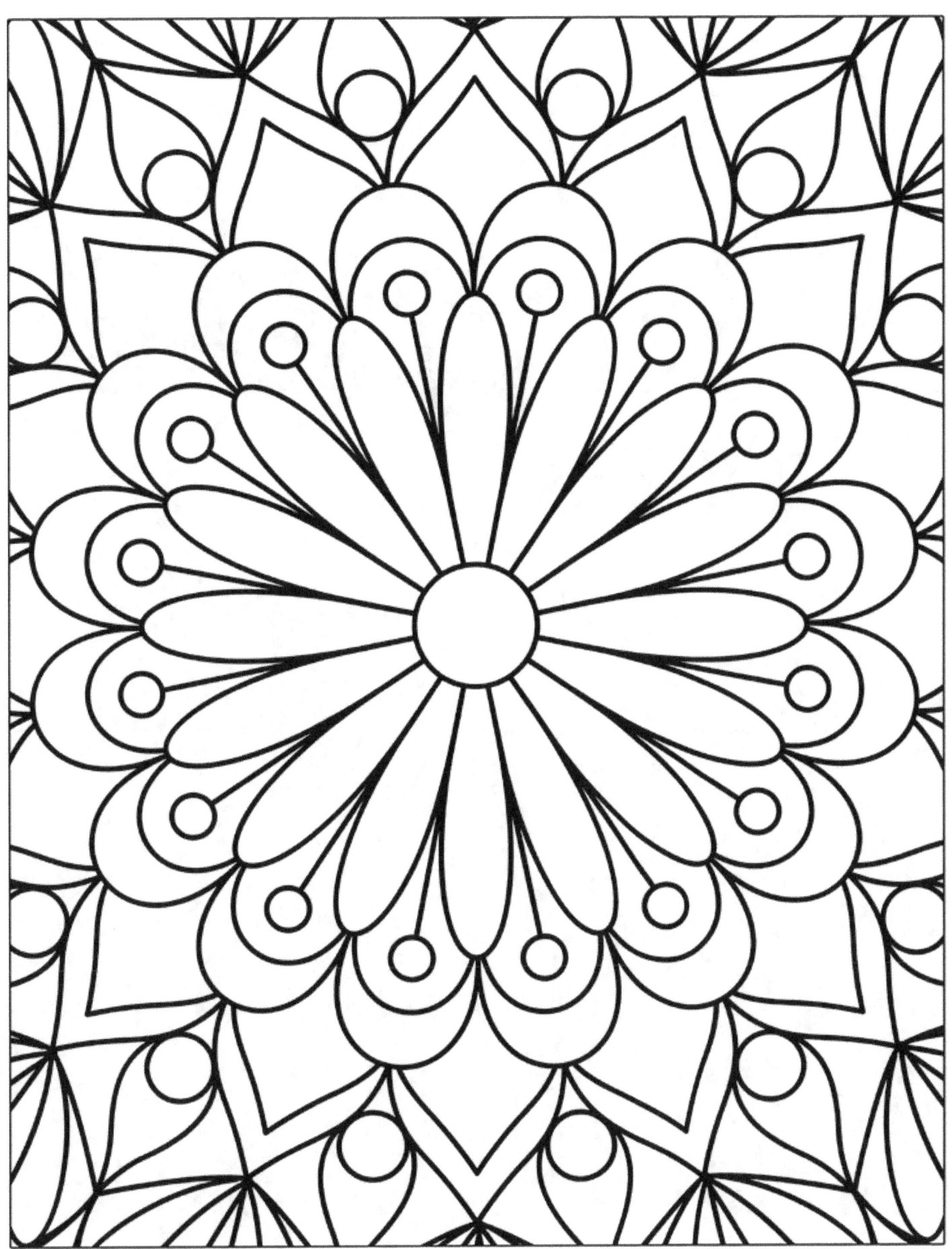

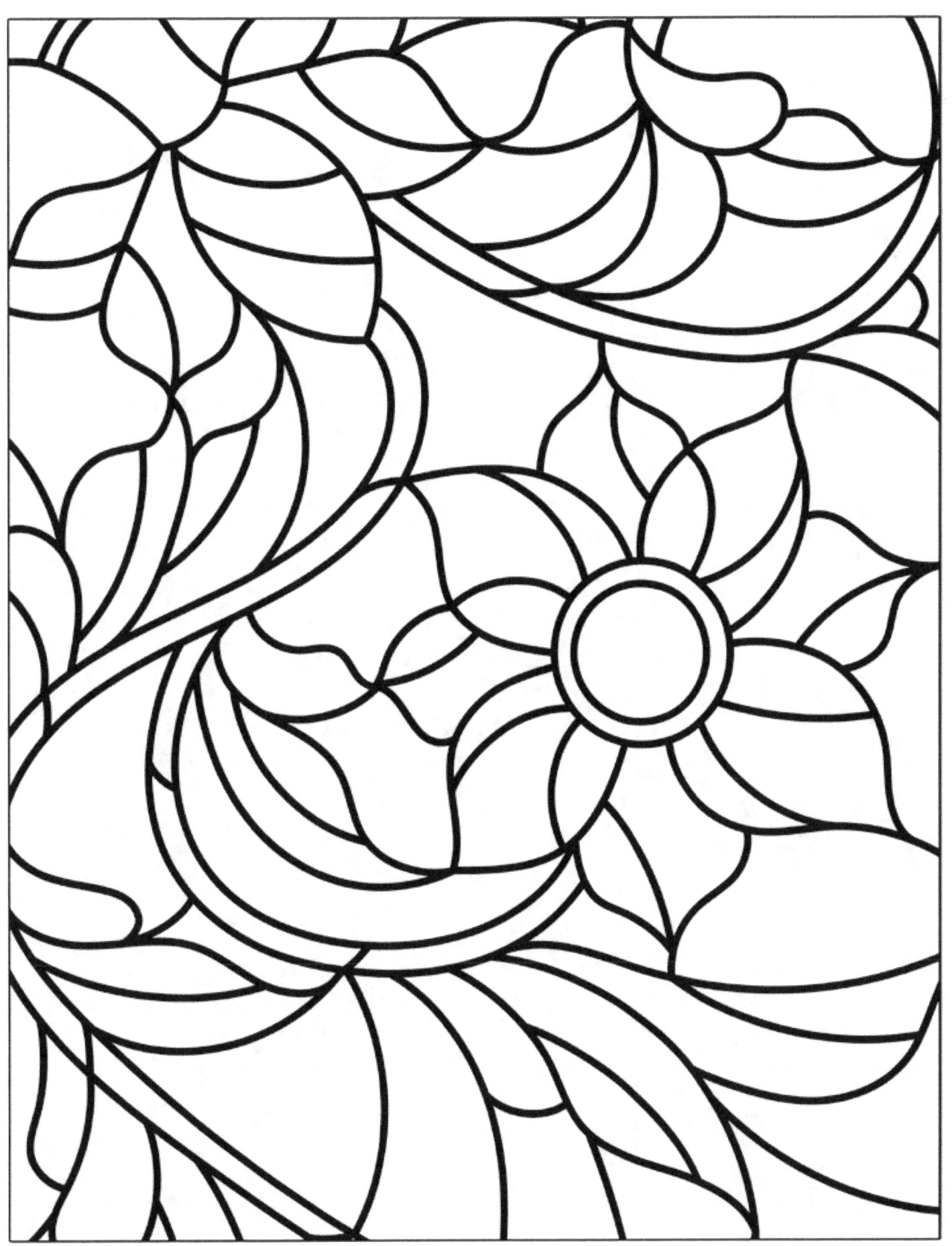

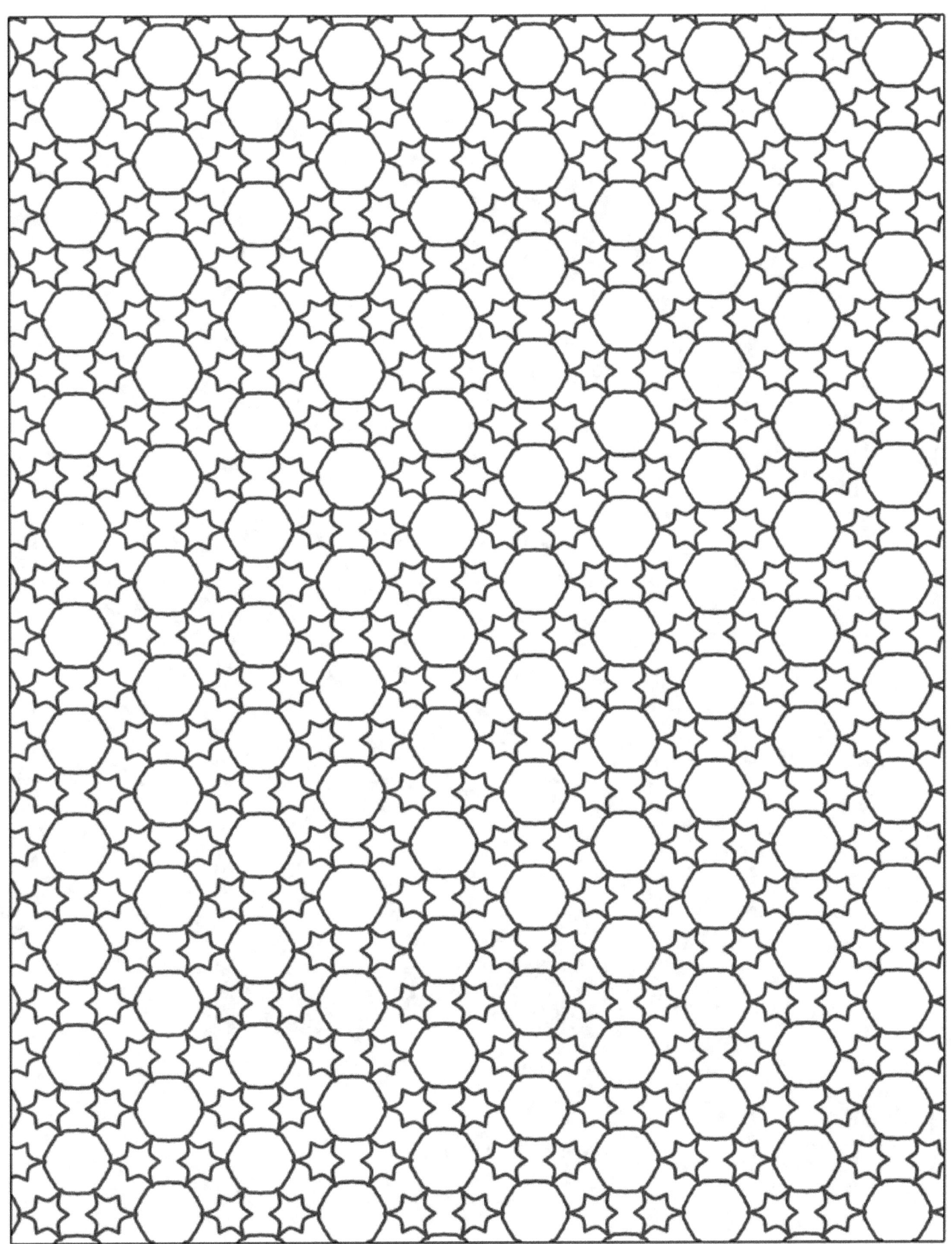

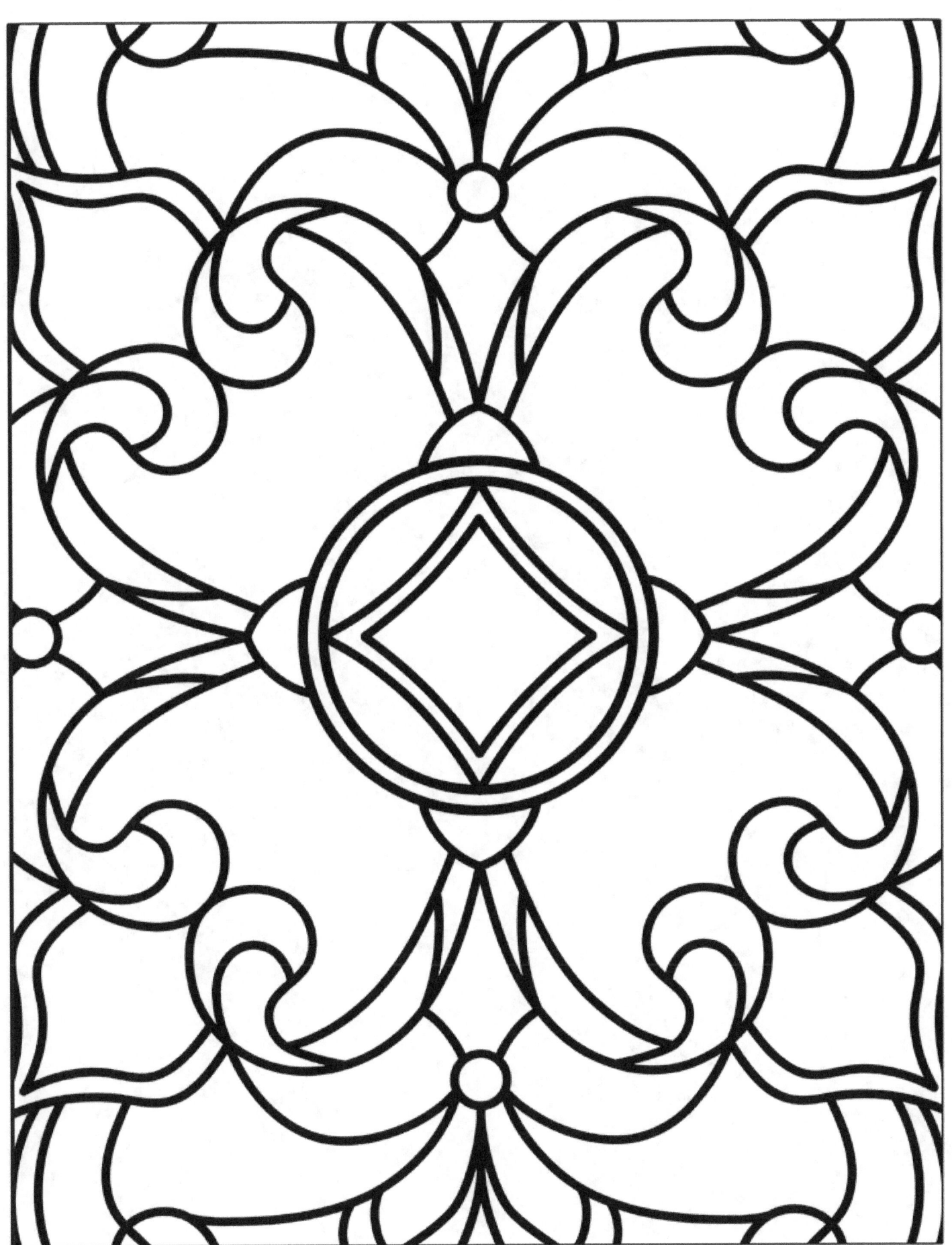

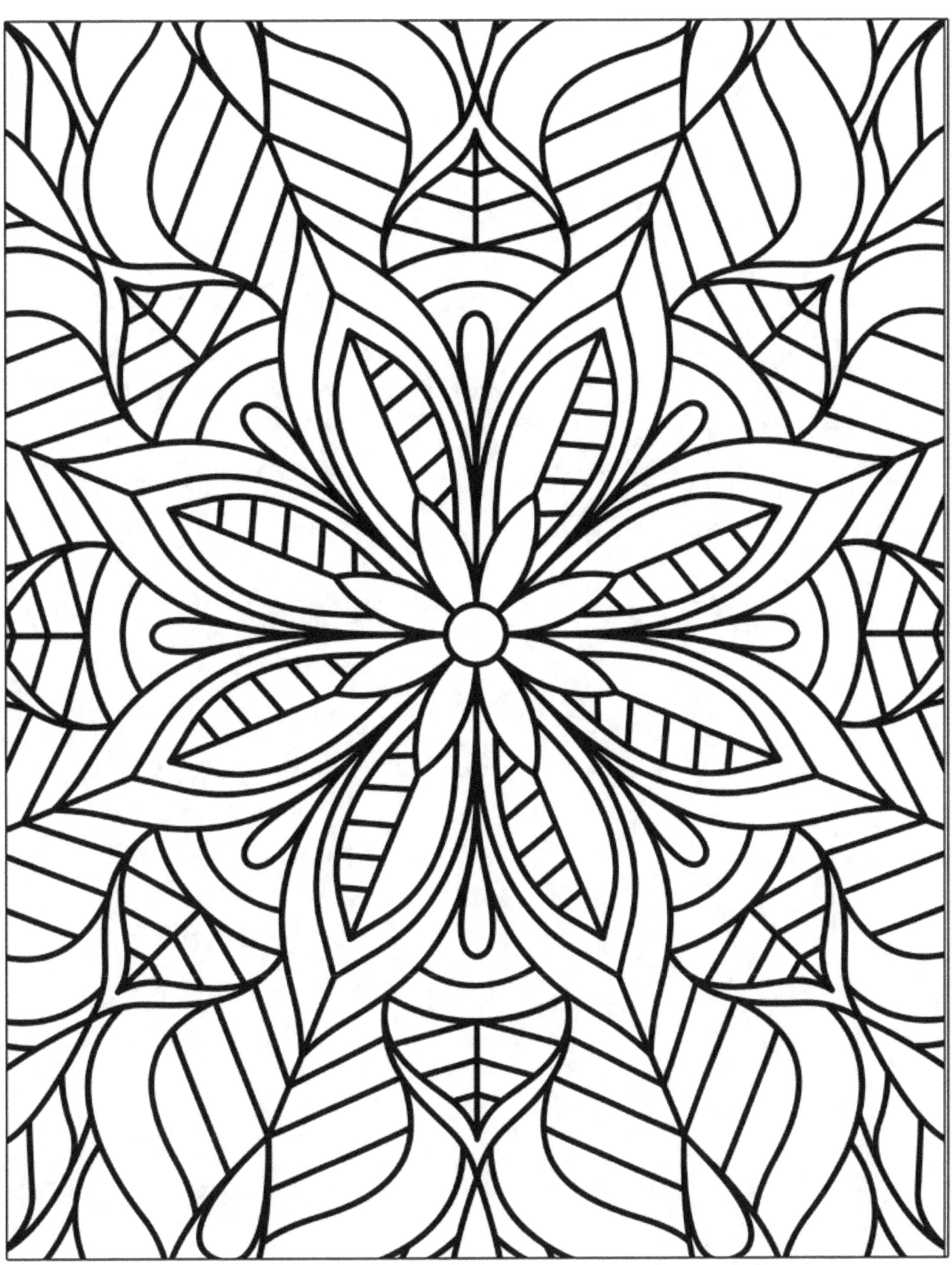

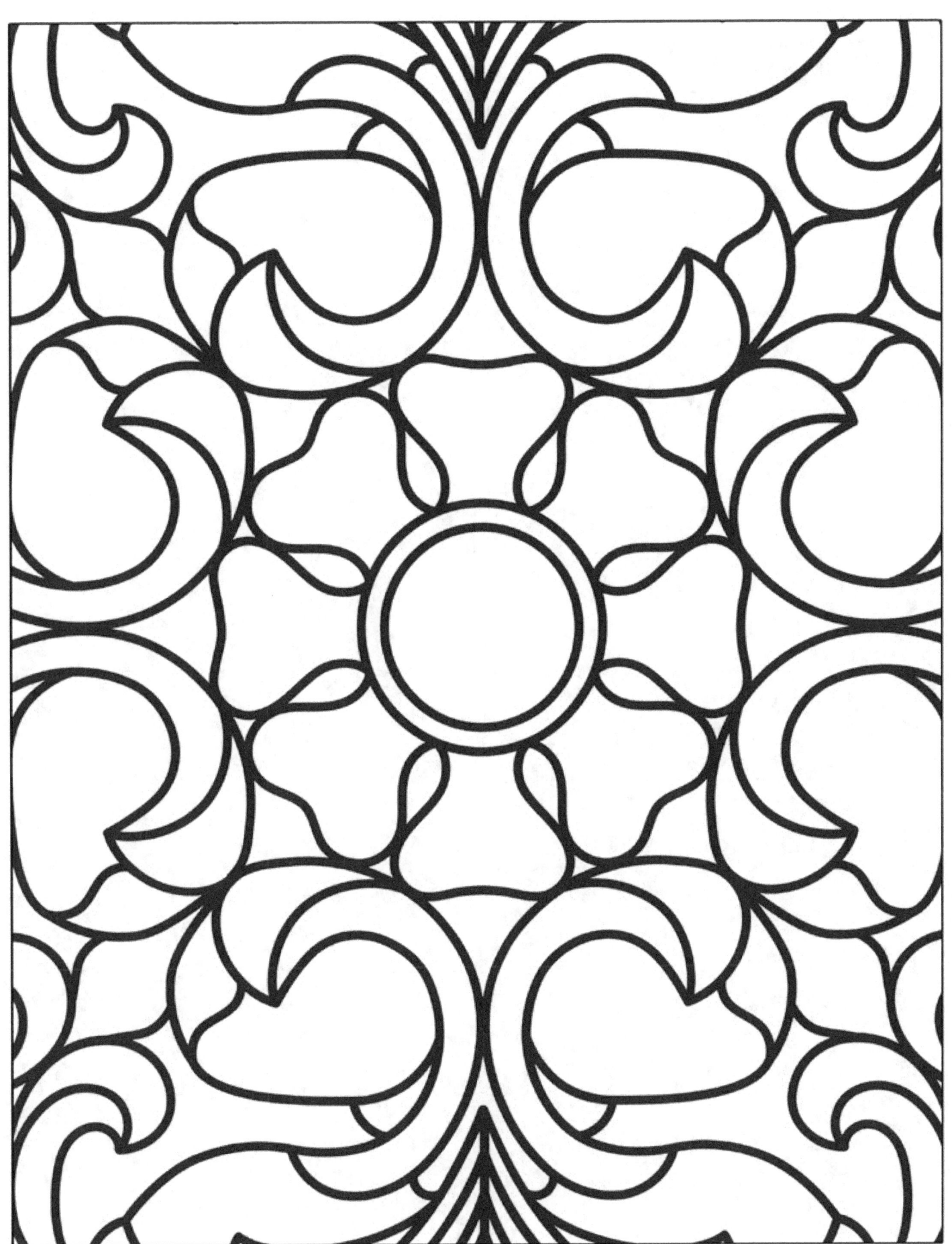

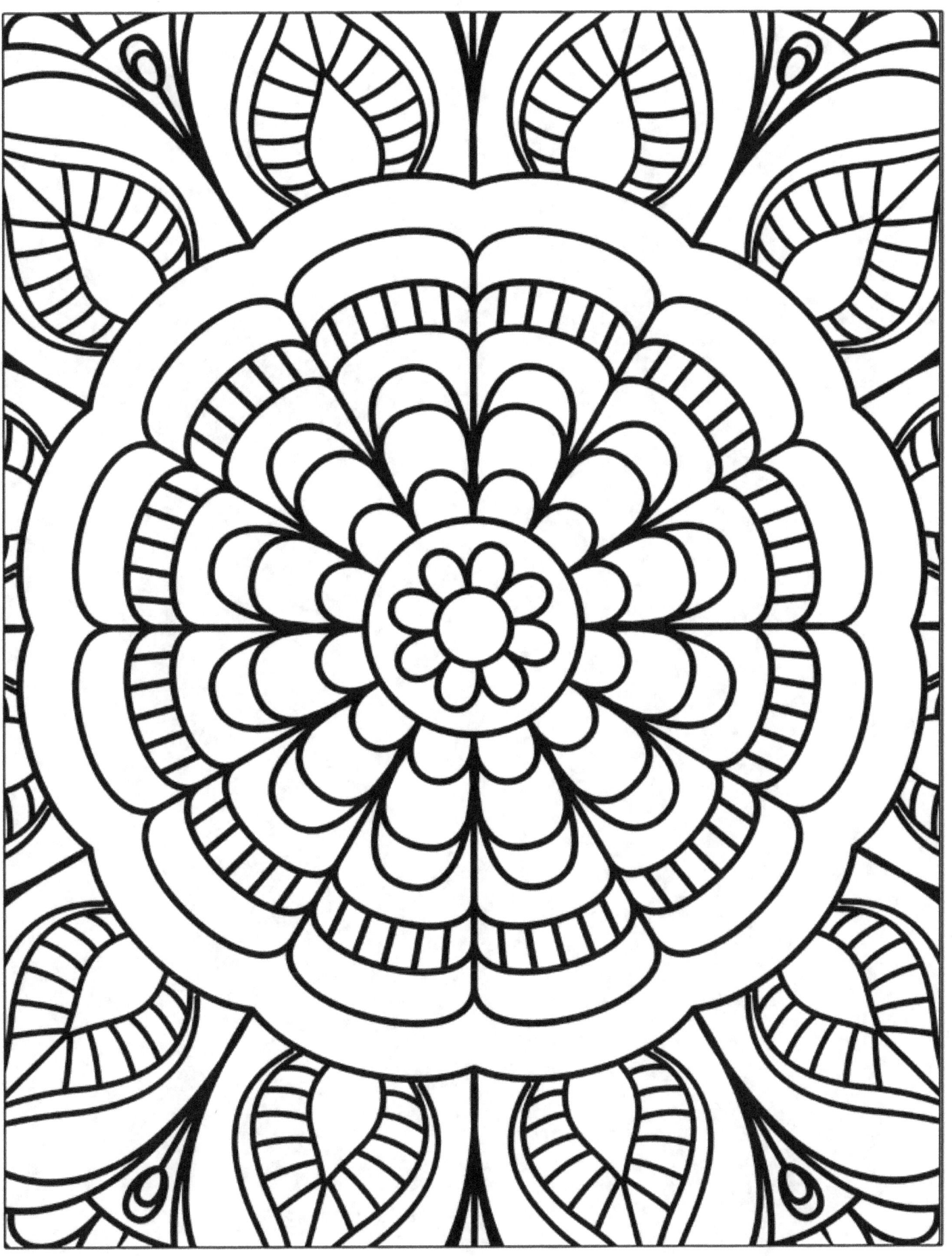

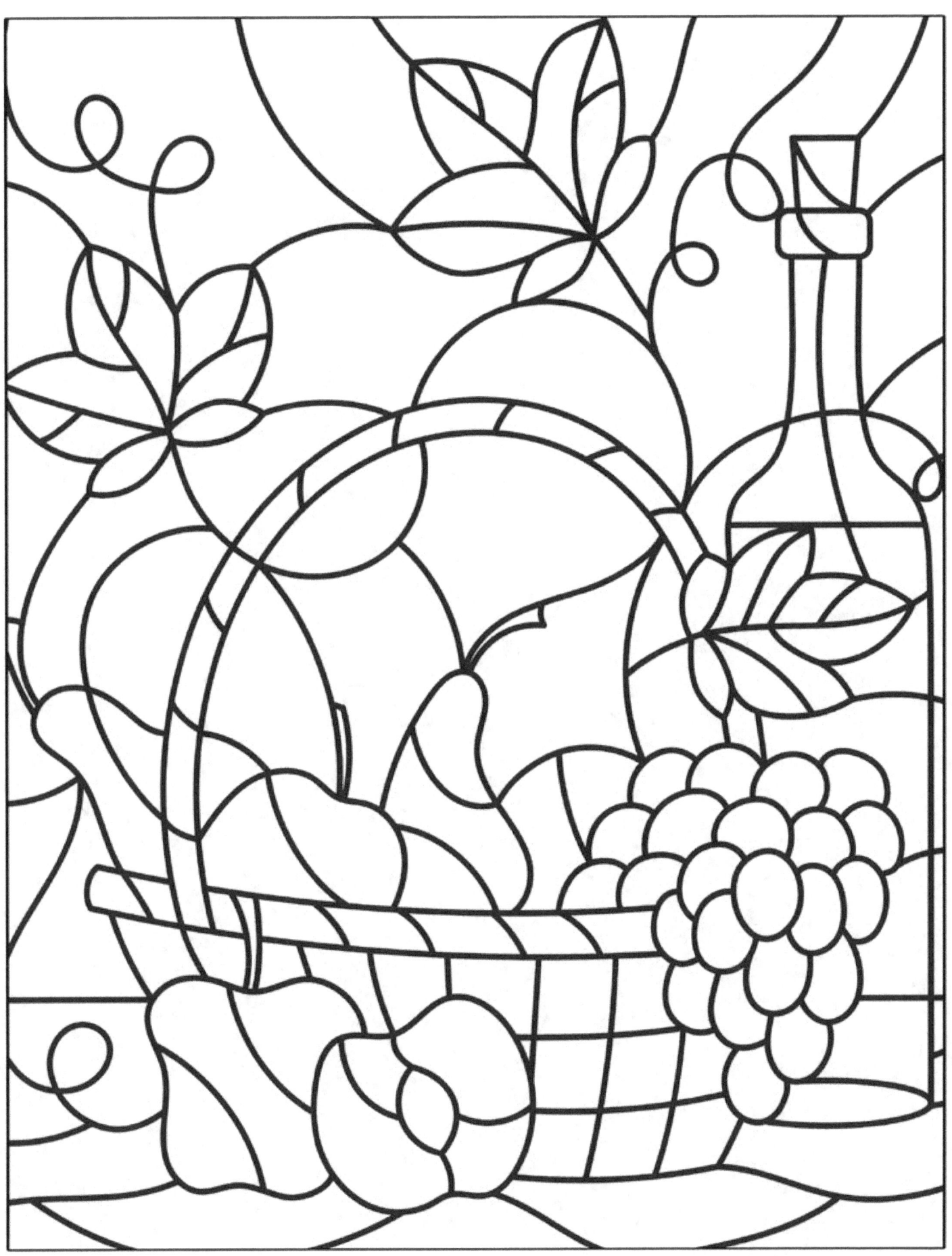

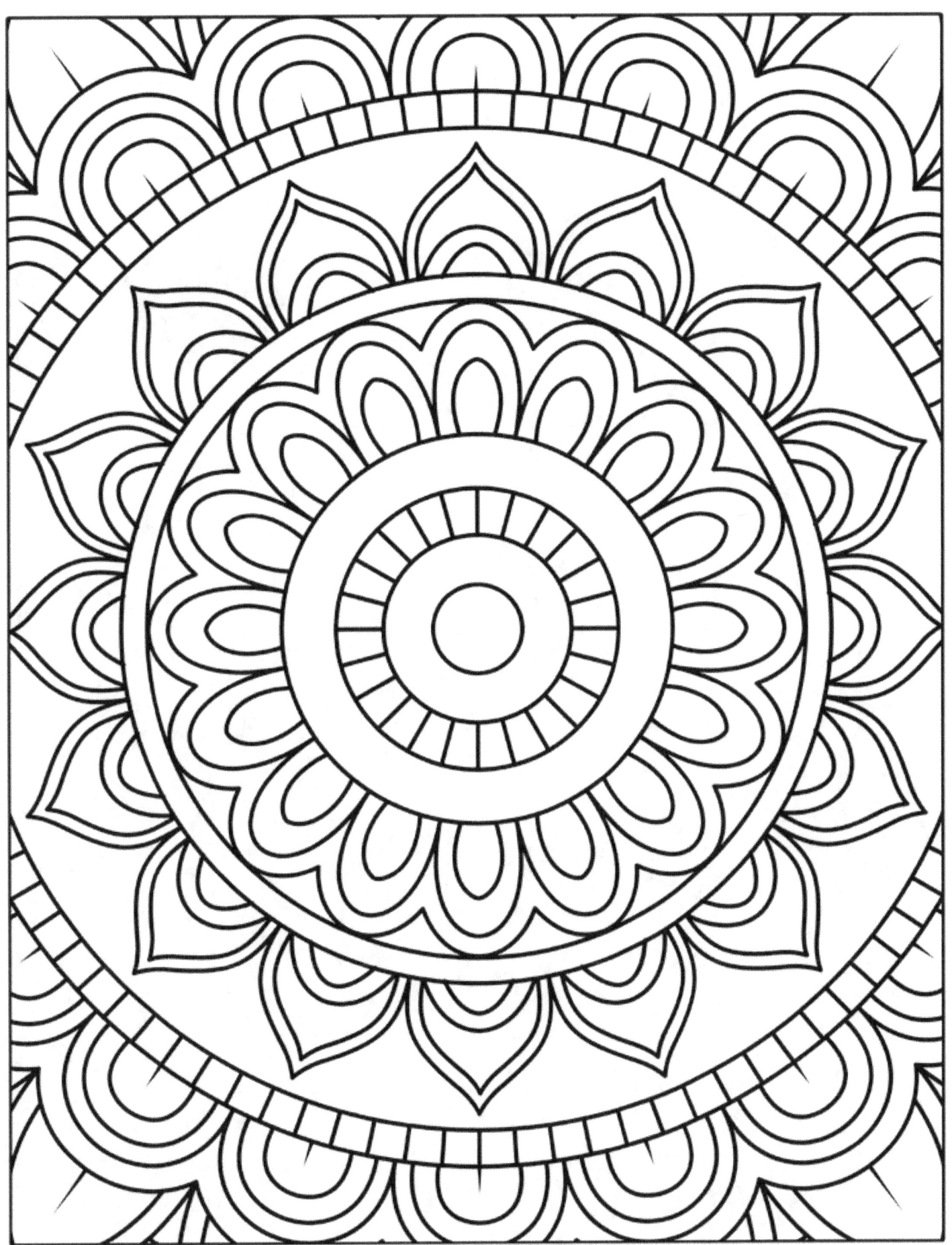

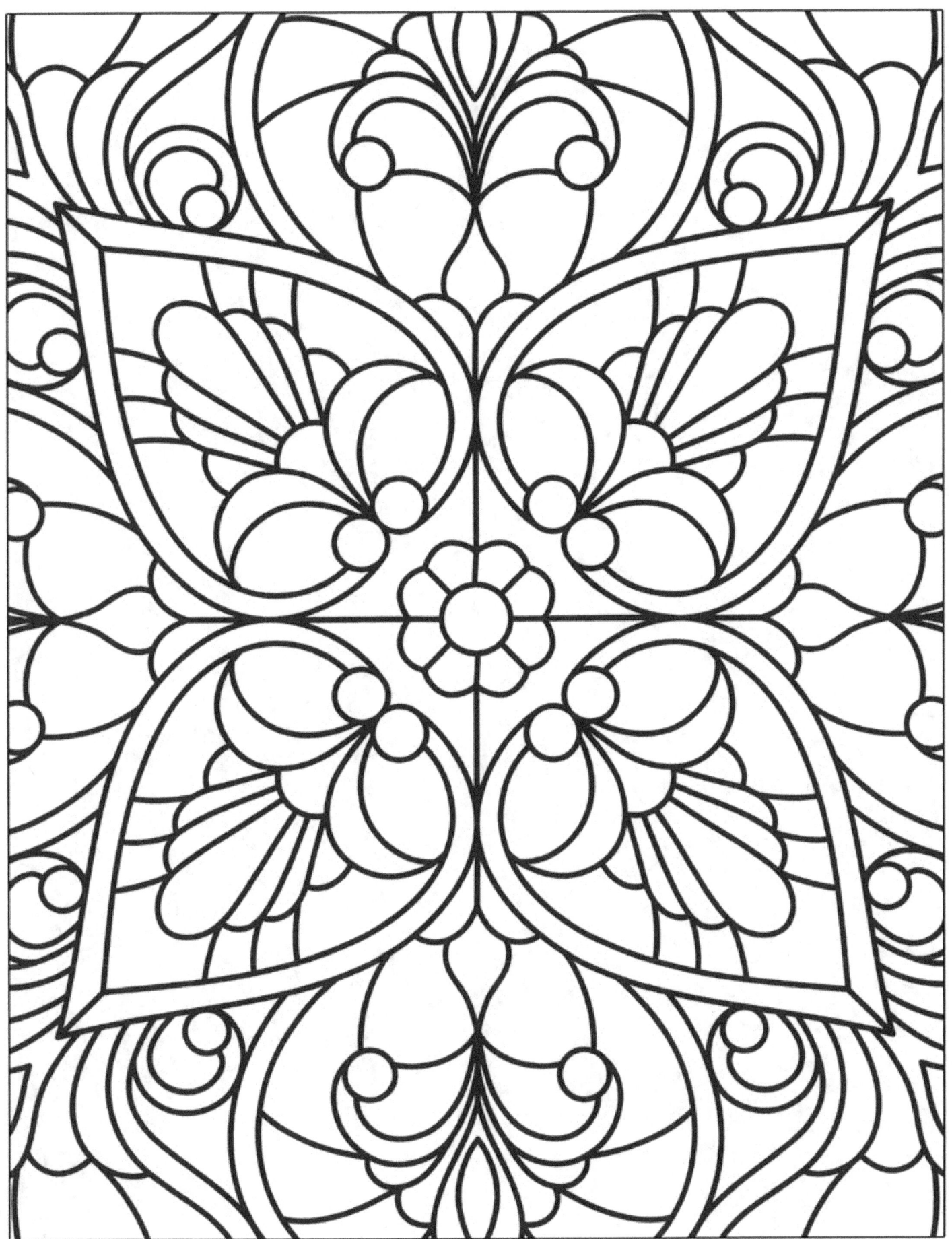

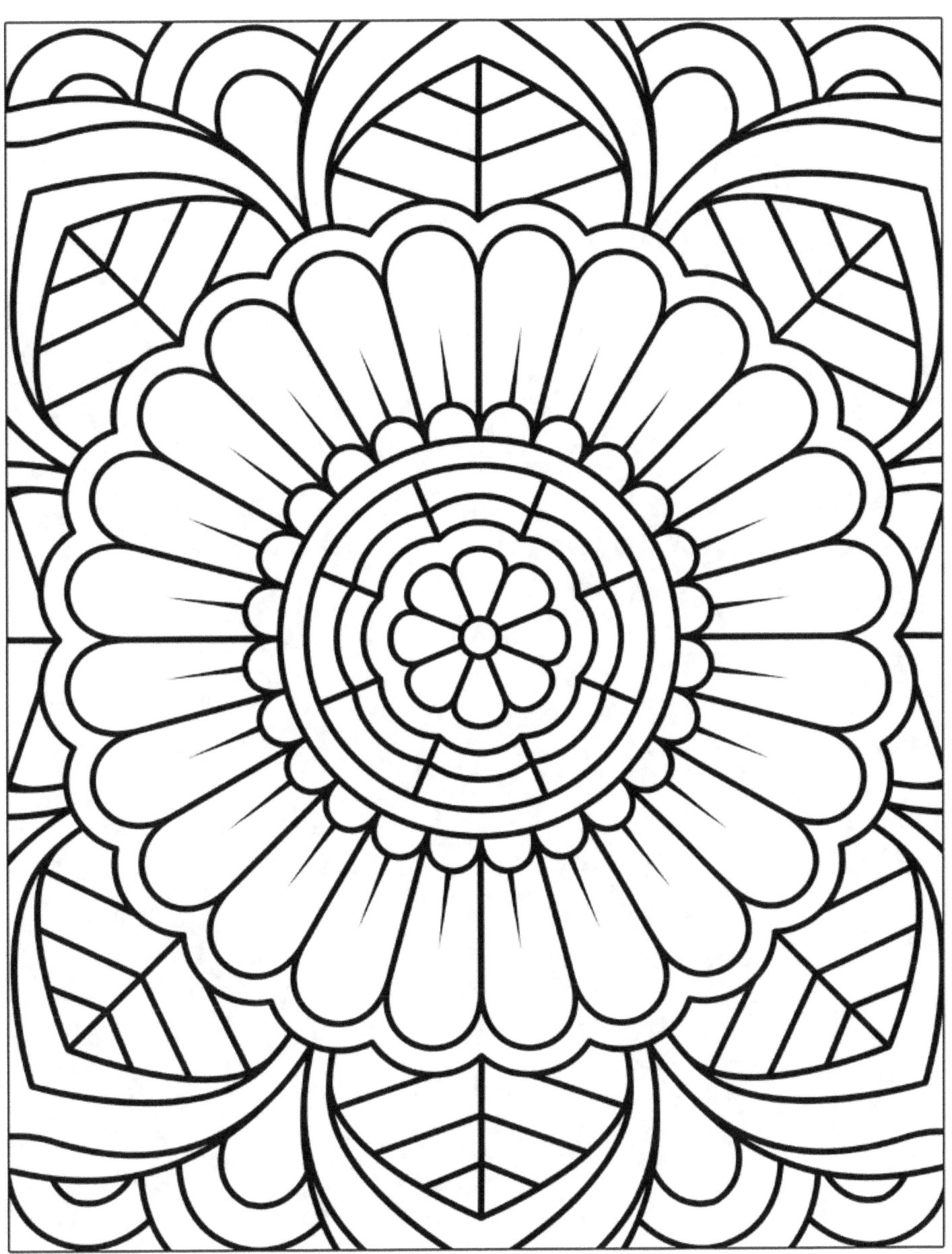

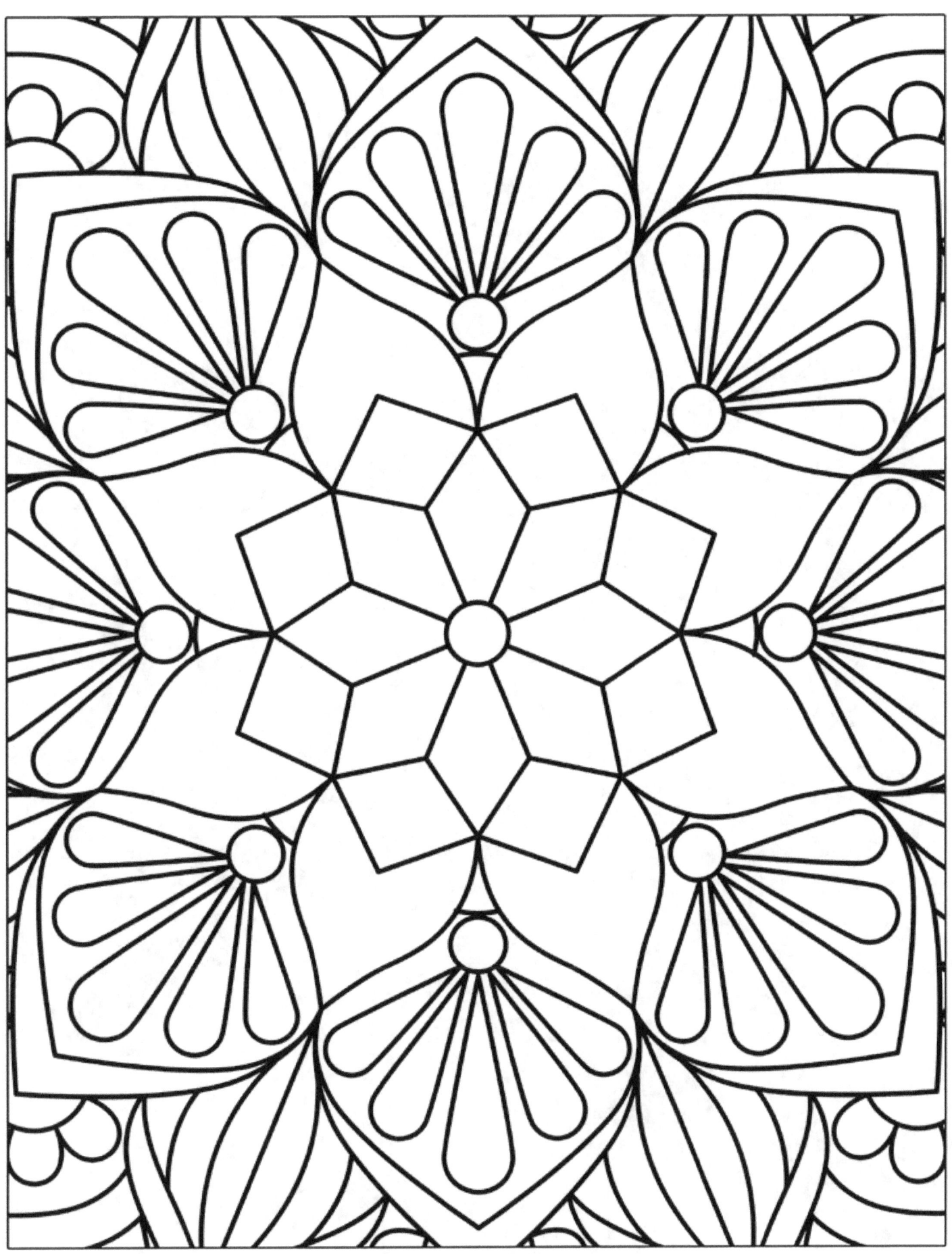

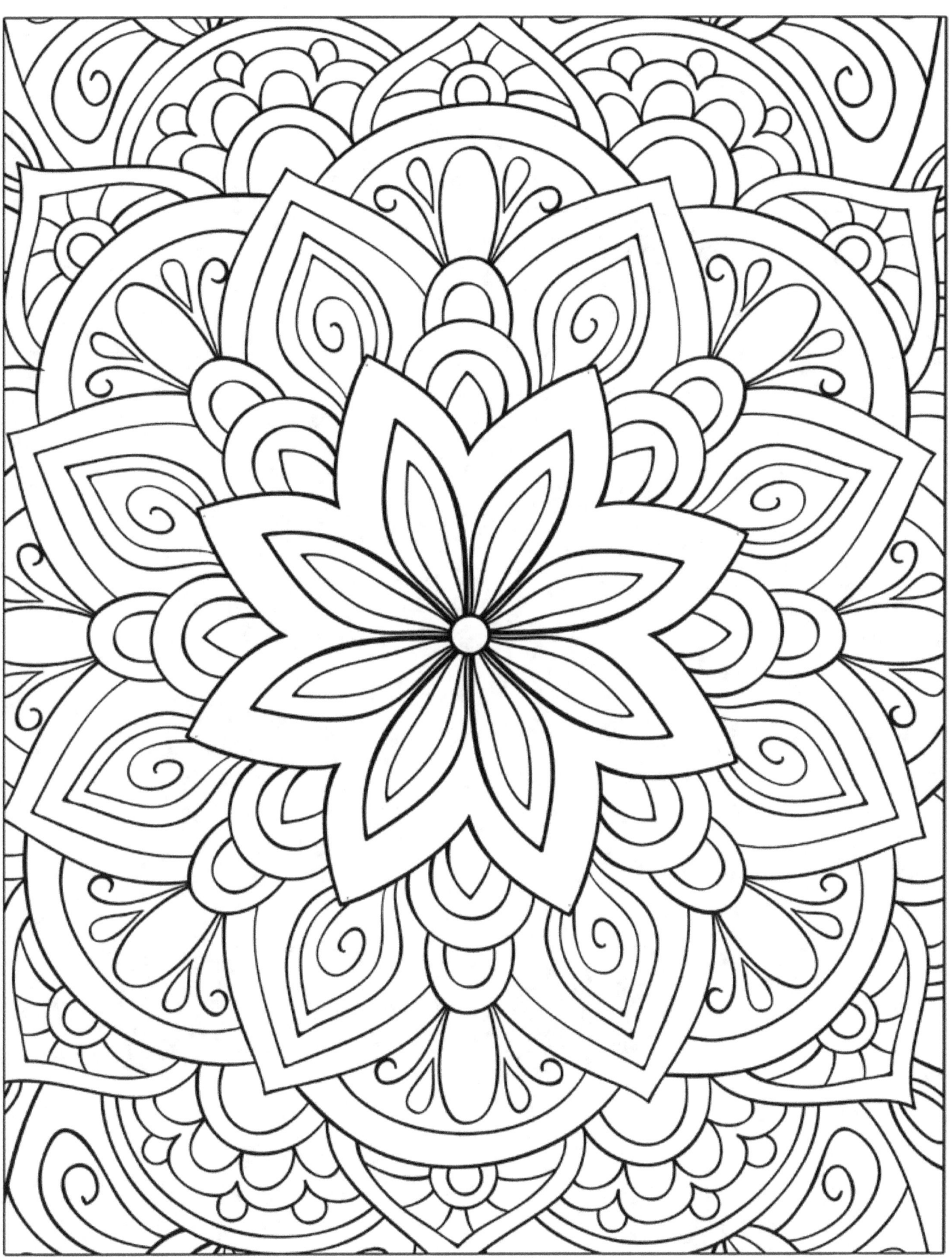

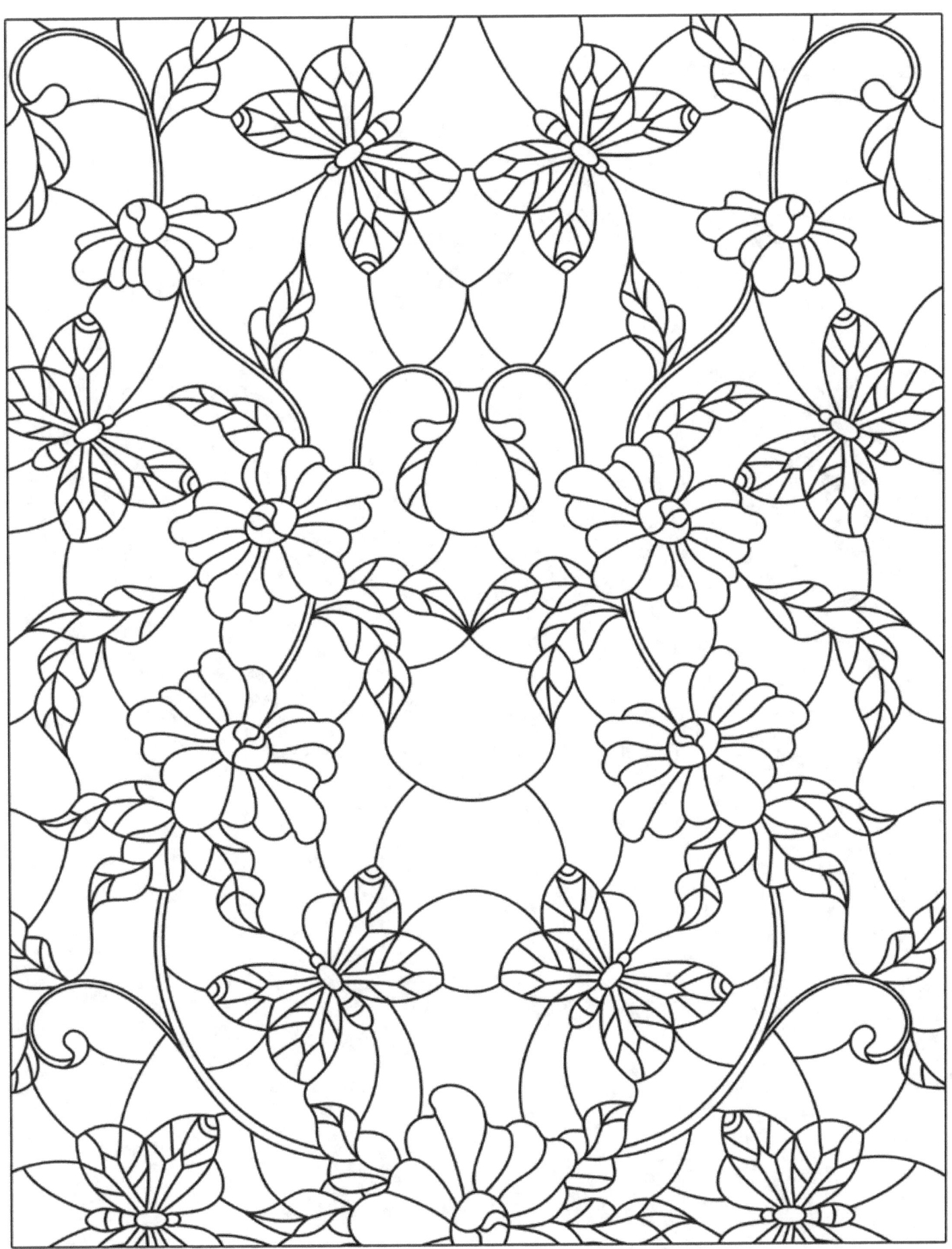

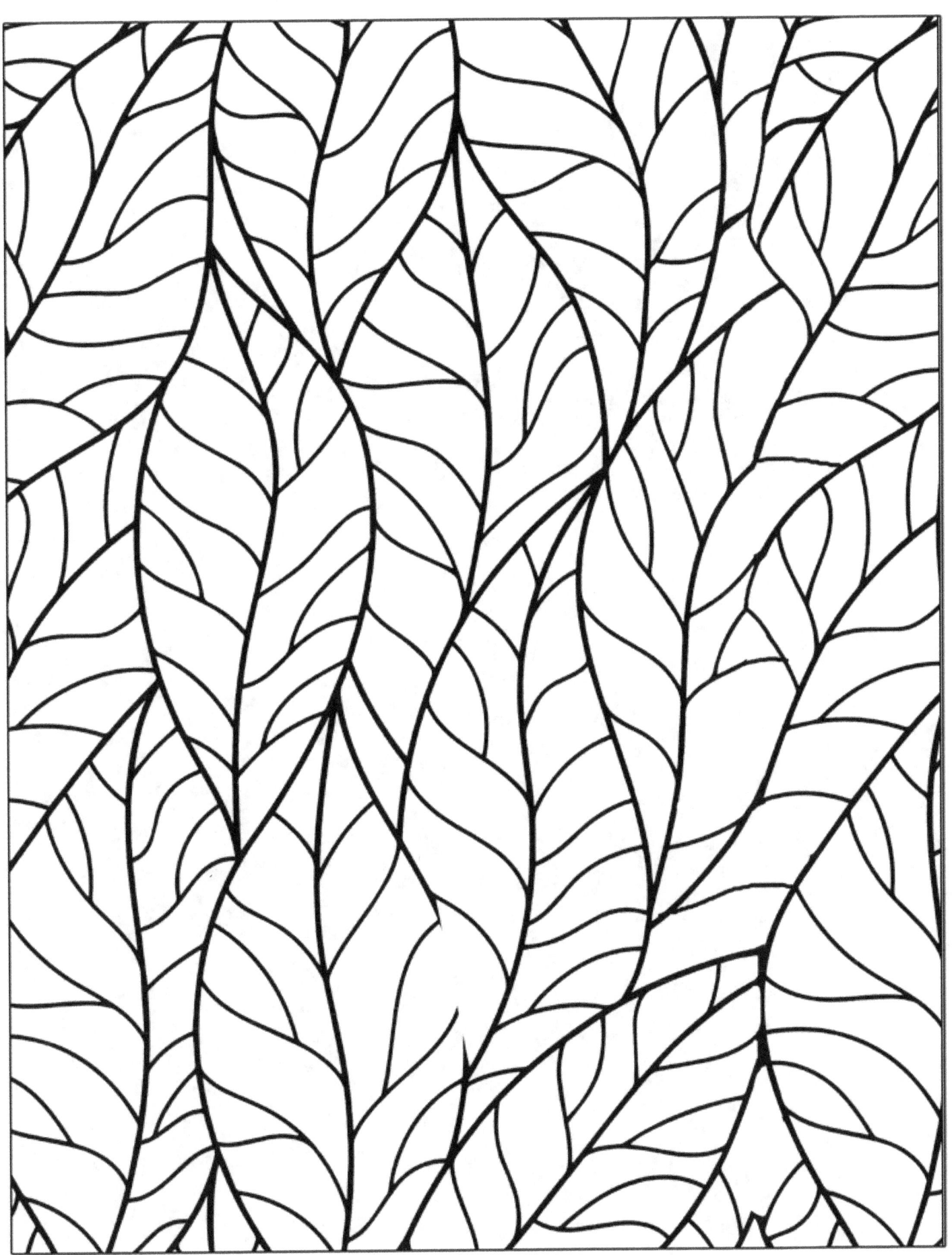

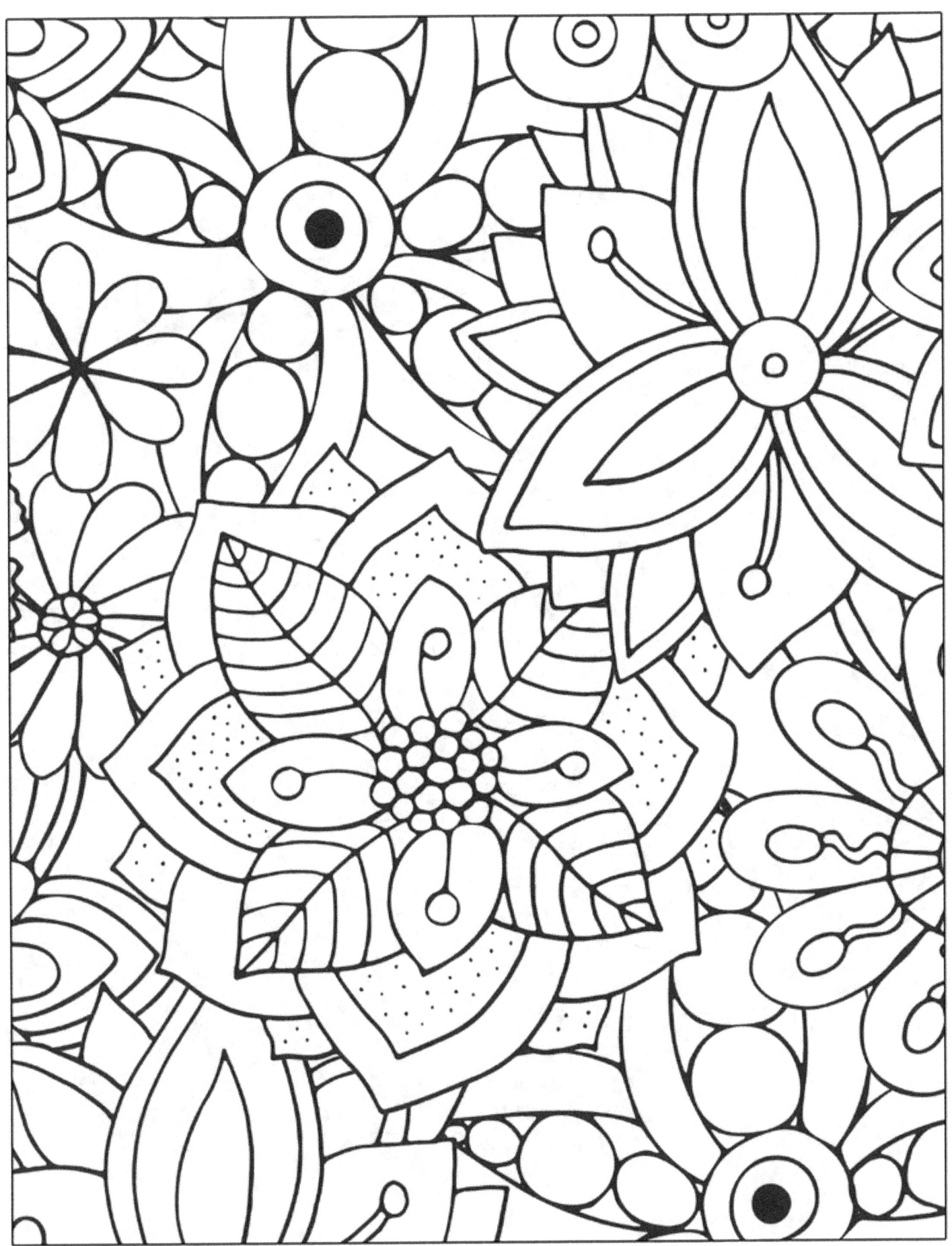

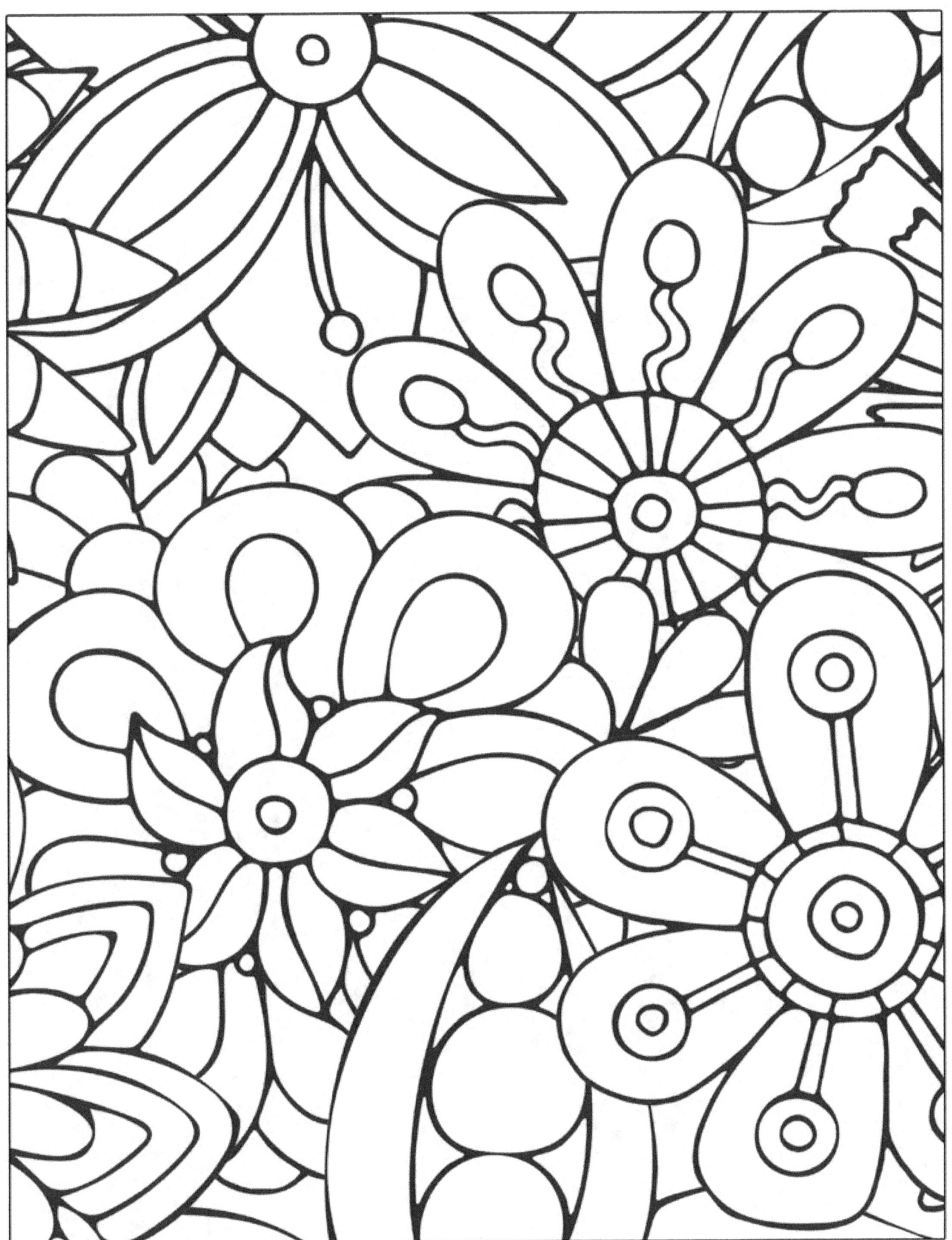

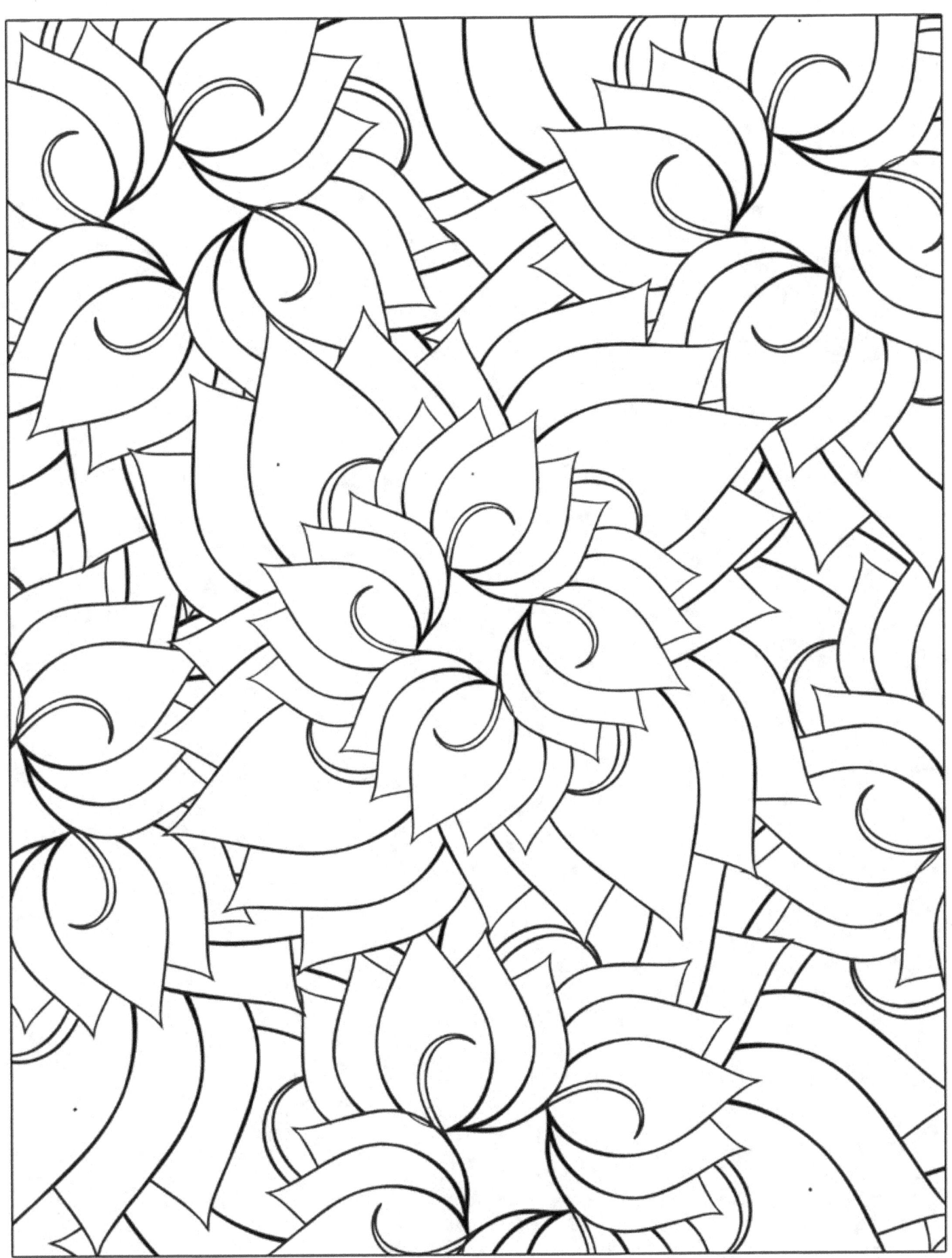

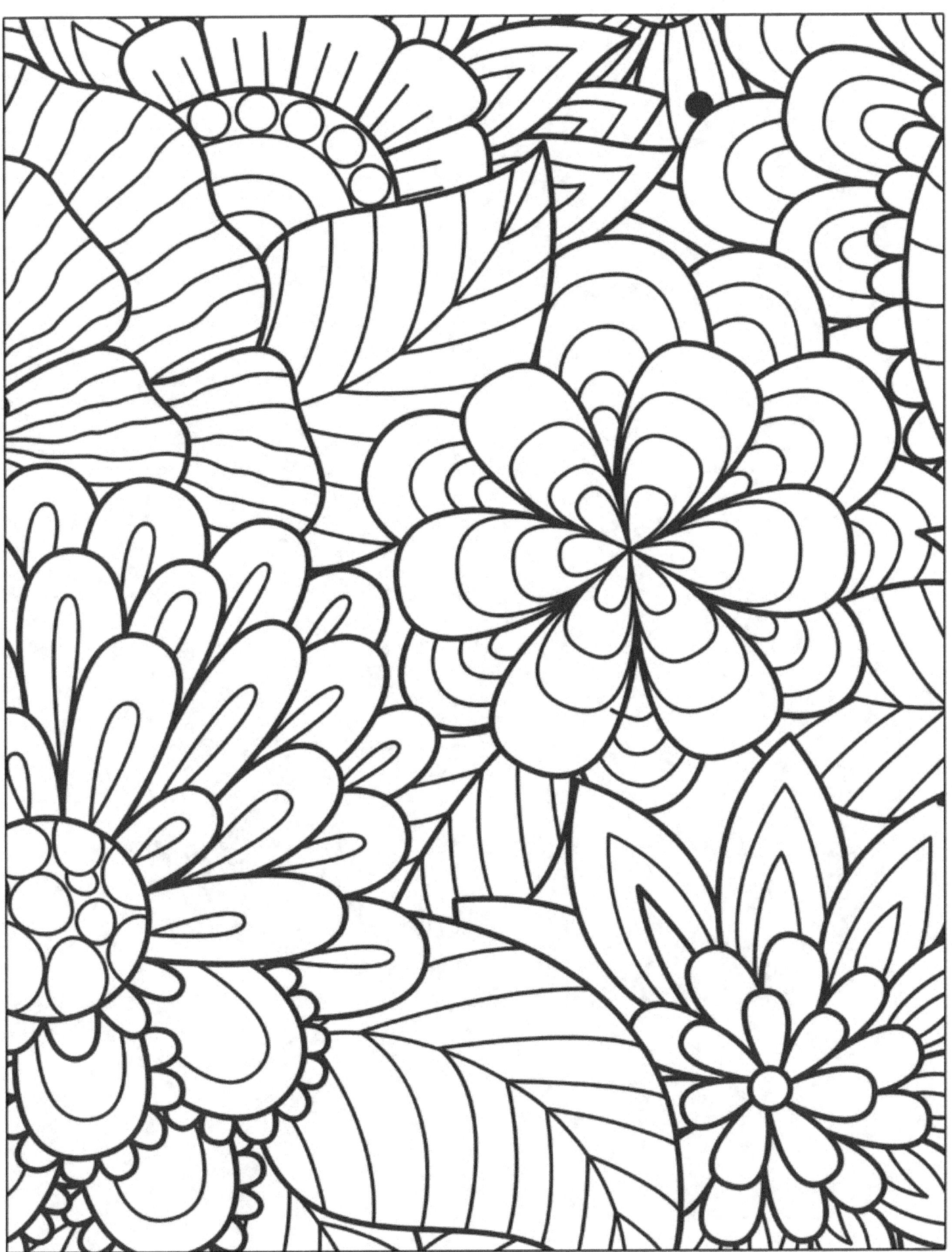

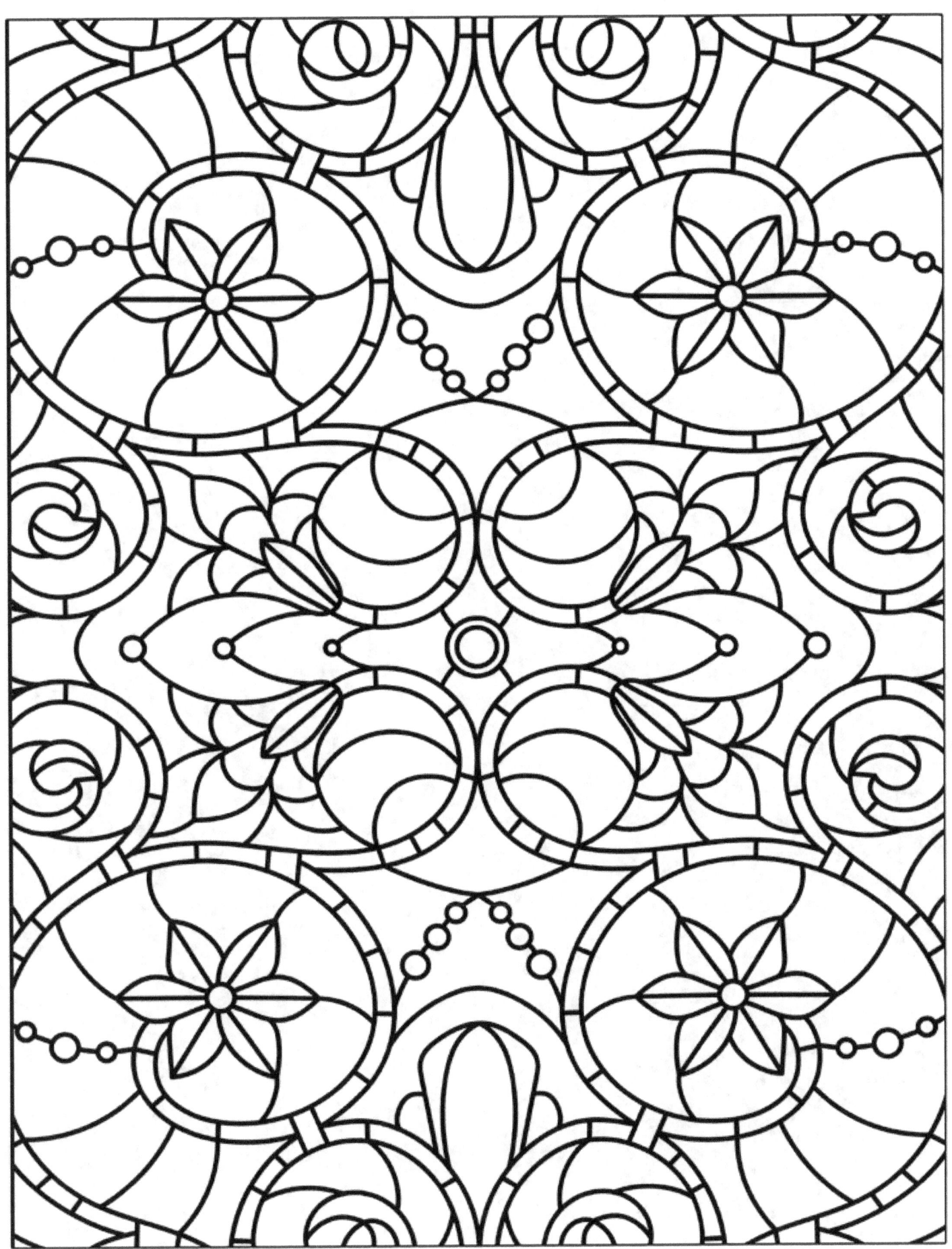

www.ingramcontent.com/pod-product-compliance
Lightning Source LLC
Chambersburg PA
CBHW080542220526
45466CB00010B/2998